IMAGES
of America

SAVANNAH
RIVER PLANTATIONS
PHOTOGRAPHS FROM THE COLLECTION OF
THE GEORGIA HISTORICAL SOCIETY

IMAGES
of America

SAVANNAH
RIVER PLANTATIONS
PHOTOGRAPHS FROM THE COLLECTION OF
THE GEORGIA HISTORICAL SOCIETY

Frank T. Wheeler

ARCADIA

Published by Arcadia Publishing,
an imprint of Tempus Publishing, Inc.
2 Cumberland Street
Charleston, SC 29401

Printed in Great Britain.

Library of Congress Catalog Card Number: 98-87134

For all general information contact Arcadia Publishing at:
Telephone 843-853-2070
Fax 843-853-0044
E-Mail arcadia@charleston.net

For customer service and orders:
Toll-Free 1-888-313-BOOK

Visit us on the internet at http://www.arcadiaimages.com

CONTENTS

ACKNOWLEDGMENTS

This book resulted from a lecture I gave as part of the spring lecture series at the Georgia Historical Society in March 1998. There is a lot of interest in the plantations among the citizens of Savannah as well as tourists visiting our city. The lecture, and this book, were both intended to provide a look at the plantation lands along the Savannah River and their use.

Any work on the Savannah River plantations is not complete without first looking at *The Savannah River Plantations*, edited by Mary Granger and published by the Georgia Historical Society in 1947. Granger's volume is a compilation of articles that appeared in the *Georgia Historical Quarterly*, which has been published by the Georgia Historical Society since 1917.

In addition to Granger's work, I relied heavily on the collections of the Georgia Historical Society. Photographs, maps, drawings, letters, and other material provided crucial information to the story of the plantations. At times, the task of searching the Society's collection for images to use in this book seemed overwhelming. It would not have been completed in a timely manner without the help of the library and archives staff at the Georgia Historical Society. Helping me in my quest for photographs were Amie Wilson, Mandi Johnson, Kim Ball, Jessica Burke, and Mary Beth D'Alonzo.

Several people outside of the Georgia Historical Society also provided assistance and information, and I am indebted to them. Included were Hugh Golson, Beth Reiter, Patricia Reese (Georgia Ports Authority), Gerald Noakes (National Gypsum Company), Laurice Fetzer, and Bill Hopkins. There were many more people that I called upon but it is impossible to list everyone.

Finally I want to acknowledge my wife, Paige, and my two young sons, Nathan and Duncan. They endured my constant evening reading of background information in preparation for the March lecture. They also gladly and patiently rode in the car on many trips, planned and unplanned, in and around the plantation sites while I looked around and took approximately three hundred photographs.

INTRODUCTION

Many tourists visit Savannah, Georgia and ask the same question: "Where are the plantations?" From Savannah to Brunswick, coastal Georgia was covered with profitable plantations prior to the Civil War. A handful of structures from coastal plantations still exists, but some plantation sites are represented today only by a historical marker or possibly a museum or historic site. However, most of the former plantation sites show no resemblance to the once thriving way of life they enjoyed. These sites are occupied by industry, have become subdivisions, or are considered wilderness. The sites of the Savannah River plantations are primarily industrial in 1998. There are a few areas that are considered wilderness, and in general, there is very little physical evidence that the plantations ever existed.

In the original plan of the Trustees of Georgia, the colony had three purposes: philanthropic, defensive, and agricultural. The colony provided both an economic opportunity for destitute Englishmen and a buffer between South Carolina and the Spanish. The agricultural pursuits of the colony were not as successful as expected in the early days, and the Trustees realized that the system had to be revamped.

Plantation development was slow in Georgia for many reasons, including the manner by which land was granted. The Trustees granted 50 acres to each farmer, who in turn fulfilled the agricultural purpose of the colony and bore arms in its defense. In the minds of the Trustees, large land grants would only burden their progress. There were, however, "adventurers" who came to Georgia at their own expense and petitioned successfully for additional land, but this land came with restrictions.

In addition to the land restrictions and the petitions required to receive more than 50 acres, all grants were *aile male*, which meant that if the landholder left no male issue, the land reverted to the Trust upon the death of the owner. This form of grant existed in Georgia until 1739. There are recorded cases of plantation owners letting their land fall to ruin due to not having any male issue. If a planter invested a great deal of money into the plantation, this money would be lost by his female heirs and any improvements made would be enjoyed by whomever was given the land by the Trustees.

Another factor hindering plantation development in Georgia was the prohibition of slavery by the Trustees. In addition to the ban on slavery, the colony did not allow lawyers, Catholics, or liquor. However, the ban on slavery had the largest impact. Landholders began to realize that they could make a profit by growing rice in the marshes, which had previously been considered

useless. Developing and maintaining a rice plantation was extremely labor intensive, and Georgians could see the huge profits being made by their neighbors in South Carolina who could use slave labor. People in the rural areas of Georgia began to migrate to South Carolina, where they could earn a livelihood with fewer restrictions. The Trust faced the threat of the abandonment of the colony.

In order to encourage people to remain in the colony, the Trustees took dramatic steps. On May 17, 1749, they agreed to permit slavery in the colony, and on March 19, 1750, the Trustees decided to enlarge landholdings and to extend grants to absolute inheritance. Absolute inheritance would apply to future grants. With the dramatic steps taken by the Trustees, plantations in Georgia were flourishing by the end of the 18th century.

The land along the Savannah River has always been considered some of the most valuable in Chatham County. During the plantation era, this land was used to grow rice, indigo, cotton, tobacco, and a variety of other crops. Some of these were experimental, and rice was the most profitable crop. Land use eventually turned from agricultural to industrial. This land was the most desired by plantation holders and today is the most desired by industry.

The Savannah River Plantations was written with the hope of documenting history that is being lost. Understandably, the numerous industries moving to the Savannah River sites were not as interested in the land's past as they were in the land's future. Regrettably, no structures exist on the Savannah River plantation sites in Chatham County, but all can't be blamed on industry. Union soldiers played a significant role in the destruction of plantations along the Savannah River.

My goal in putting together this book was to provide insight into the land and its ownership and use. This is by no means a definitive history of the Savannah River plantations, however, this is the only photographic look at the plantations. Photographs from the collection of the Georgia Historical Society were coupled with maps and current images in an attempt to identify former house sites and then record their current use.

For more-in-depth information on this topic, one should read The Savannah River Plantations, edited by Mary Granger and published by the Georgia Historical Society in 1947.

One
RICHMOND OAKGROVE

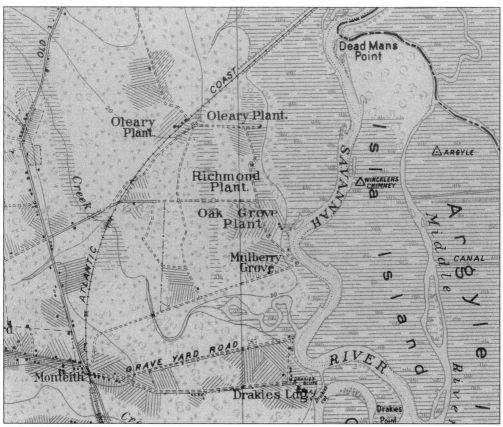

Richmond Oakgrove is the northernmost Savannah River plantation in Chatham County. This plantation originally consisted of several tracts which were united in the late 19th century. The original four plantations were Richmond and Kew, Morton Hall, New Settlement, and Oakgrove. Under the original grants these lands provided no benefit to the Georgia Colony. Richmond and Kew Plantation is actually one unit divided by another tract.

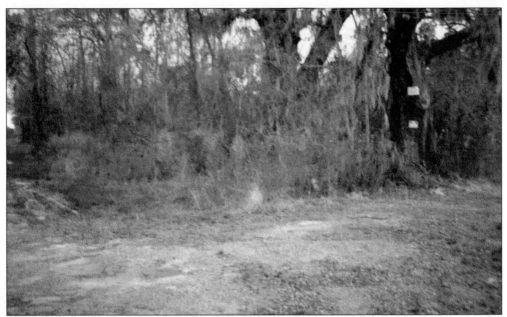

In 1735 Oakgrove and Morton Hall were the northern area of Joseph's Town. Patrick Mackay was granted the 500-acre tract of Oakgrove, and his brother John was granted the 500-acre tract of Morton Hall. Pictured here is a section of the road between Richmond and Mulberry Grove. The right fork leads to Mulberry Grove Plantation.

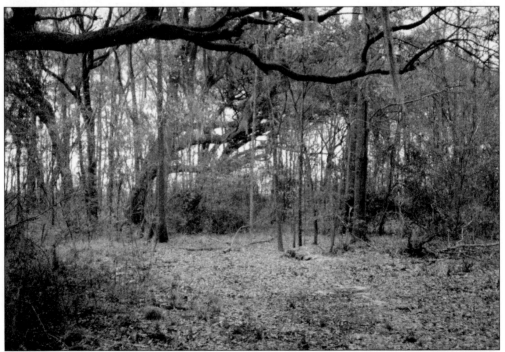

Beyond the trees can be seen a marshy area that was formerly rice fields. The houses and other buildings on the plantations on this part of the Savannah River were positioned on a bluff overlooking the rice fields. This land is currently owned by Union Carbide.

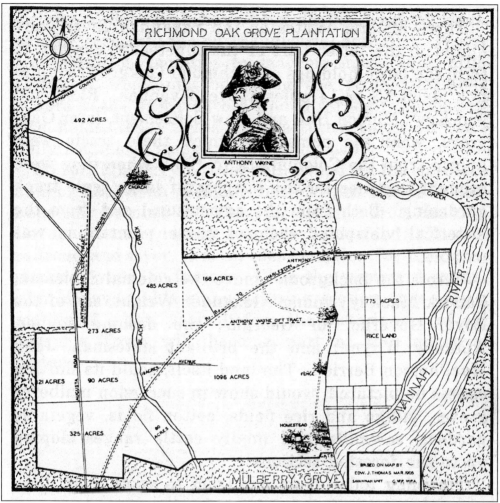

This map shows the numerous tracts which make up the Richmond Oakgrove Plantation. Mulberry Grove is to the south. Mulberry Grove and the Richmond Oakgrove plantations shared a common road from the Augusta Road. As the visitor approached Mulberry Grove, a road to the left took him to the four Richmond Oakgrove tracts.

In 1810 William B. Bulloch of Savannah purchased the Richmond and Kew tract. He paid $12,000 for the property and owned it for 35 years. Bulloch made a great deal of money and was able to make many improvements to the property. In 1845, after experiencing financial difficulties due to the panic of 1837–1843, Dominick O'Byrne received the plantation. This photograph is of an area believed to be part of Richmond and Kew.

Richmond and Kew was purchased in 1772 by Alexander Wright, son of Sir James Wright. He enjoyed almost two years of prosperity before hostilities escalated between the Tories and Patriots. Most of the plantations along the river were held by Tories who were forced to flee their land. Alexander Wright fled but was torn between supporting his father and the king or the land where he was born. Despite his support of the patriotic cause, Wright's land was seized along with other lands that were confiscated.

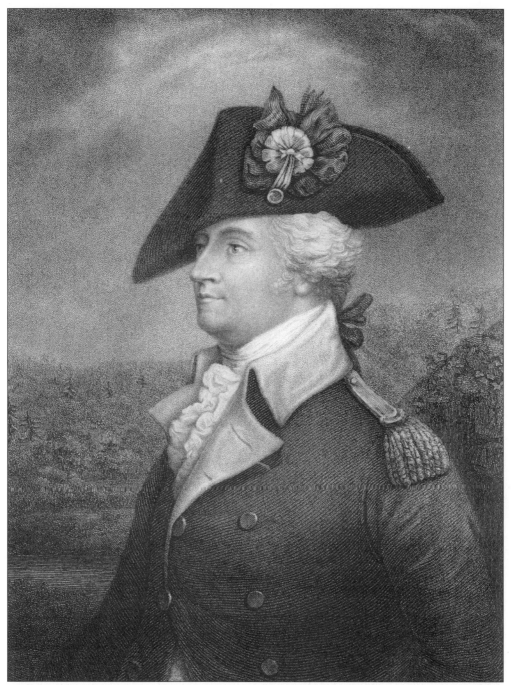

General Anthony Wayne was awarded Richmond and Kew Plantation for his service during the Revolutionary War. Wayne came to Georgia in the later years of the war and was awarded the rundown plantation in 1786. He moved to Georgia from Pennsylvania and was apparently happy with his land, as it was located next to Nathanael Greene's plantation. He was doubly happy as he had a fondness for Greene's wife, Catherine.

During the 18th and 19th centuries the primary agricultural product of Richmond Oakgrove Plantation was rice. The land was purchased in 1887 by Francis Exley, who intended to plant the higher ground away from the rice fields in truck produce. Richmond Oakgrove became one of the most profitable farms in the area, and its crops consisted of Irish potatoes, cabbage, and beets. In 1891 Exley conveyed a right of way to the Charleston and Savannah Railway Company through his land. In exchange the railroad agreed to build side tracks from the plantation warehouse. The total cost to Francis Exley for the 3,700 acres of Richmond Oakgrove was $11,787. Exley had united all 4 original tracts.

Benjamin Burroughs purchased Oakgrove from William Edward Harden in 1829. Burroughs was part owner of the S.S. *Savannah*, which was the first steamship to cross the Atlantic Ocean. He and his business partner Oliver Sturgess had shipped a large cotton cargo on the maiden voyage. Burroughs was prosperous, as is indicated through his purchasing additional slaves. He sold Oakgrove to John MacPherson Berrien in 1836. The road pictured here divides Mulberry Grove and the Richmond Oakgrove tracts.

Nathaniel Hall purchased Morton Hall Plantation from Patrick Mackay in 1761. Hall was a member of the Commons House of Assembly and had married into the Gibbons family. Hall never fully realized profits from his landholdings, as he was a Royalist and the Revolutionary War was fast approaching. Due to harassment from "rebels," Hall was forced to leave his land by 1775 to seek protection in Savannah or Charleston.

Following the Revolutionary War, Nathaniel Hall was declared guilty of treason and he was banished forever. His mother-in-law, Hannah Gibbons, purchased Morton Hall from the Confiscation Committee in 1783. Speculation was that she had purchased it for Nathaniel Hall when in fact she sold it in 1788 to her son, William Gibbons. William Gibbons was a patriot and was one of six men who seized the king's powder magazine in Savannah in May 1775.

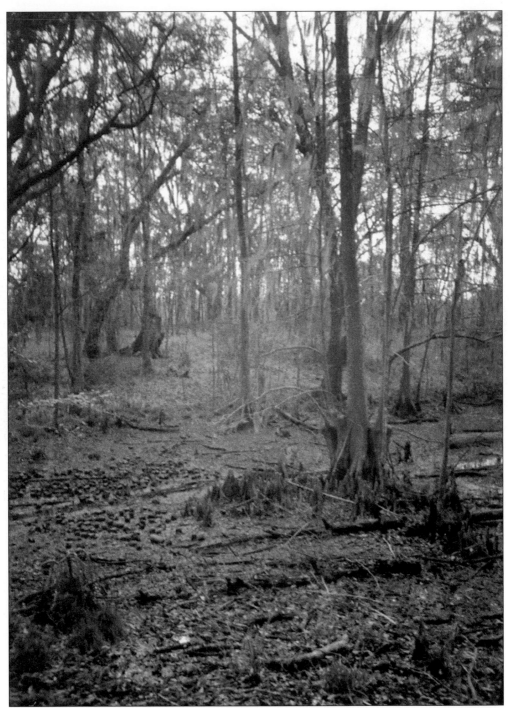

Francis Exley, who had united all of the tracts of Richmond Oakgrove in 1887, died on December 14, 1904. Following his death, his wife Alice and his son William shifted their focus for the use of the land. They decided to construct a sawmill and develop a large-scale lumber business. Pictured here are some bricks from either a rice mill or sawmill. Both had at one time been in this general area.

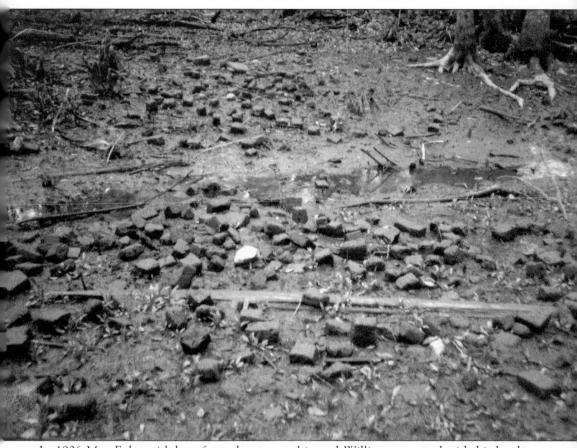

In 1906 Mrs. Exley withdrew from the partnership and William partnered with his brother Robert. A severe freeze in 1907 nearly destroyed everything, and by 1908 the brothers had left the property and were leasing it to small farmers. This photograph of the bricks was taken at low tide. The bricks probably fell into the creek bed during one of the numerous times that this land experienced flooding.

In 1909 Hubert Keller purchased 211 acres to add to the amount already purchased from the estate of Francis Exley. Keller operated a dairy farm on the land. Following World War I the Richmond Oakgrove land not owned by Keller did not even house tenant farmers. Farming had become unprofitable. This image is another angle of the bricks pictured in the two previous photographs.

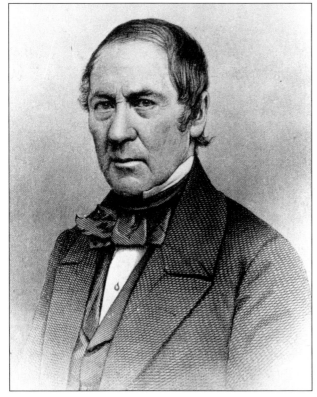

John MacPherson Berrien (pictured here) married Eliza Anciaux in 1803. She was the niece of William Gibbons and received Morton Hall Plantation upon the death of her aunt Valeria. Berrien was only 22 at the time but had already established himself as a brilliant lawyer. He had graduated from Princeton at the age of 14 and was later referred to as the "honey tongued Georgia youth." In 1836 he added to his holdings with the purchase of Oakgrove. Berrien died in 1856 and his will stipulated that Oakgrove and his slaves be held together until his youngest child came of age in 1865. In dire financial straits, the family began selling the property in 1863. John MacPherson Berrien has the distinction of being the first president of the Georgia Historical Society.

Two
MULBERRY GROVE

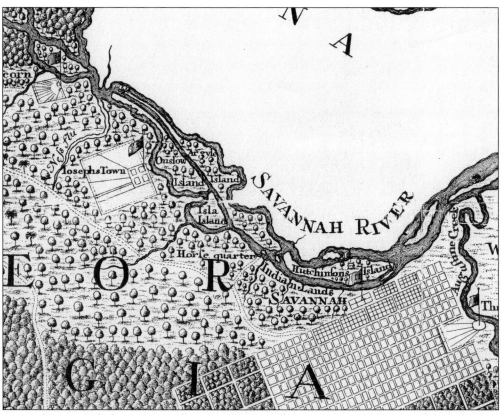

General James Oglethorpe originally set aside an area known as Joseph's Town. This area was in the Oakgrove area but was primarily on the Mulberry Grove site. It was intended to serve as an outpost and allow closer relations with the Native Americans. The land of Joseph's Town was originally granted to John Cuthbert, Patrick Mackay, George Dunbar, Thomas Bailey, and Archibald McGillivray. These men petitioned in 1735 for self-government and for the admission of slaves into the colony. They were denied both.

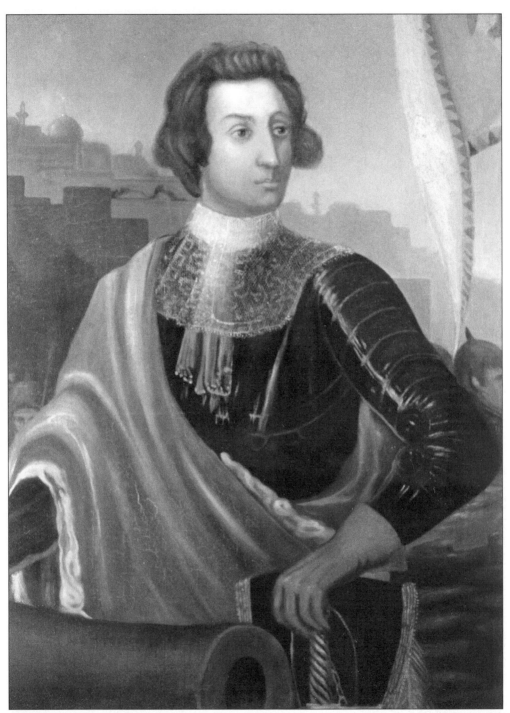

General James Oglethorpe was the founder of the colony and arrived at Yamacraw Bluff with passengers from the *Anne* on February 12, 1733. Four things were originally made illegal in the colony. The four things were slaves, lawyers, Catholics, and liquor. Of all four, the lack of slaves had the largest impact on the colony, as this led to slow plantation development. This photograph is of a portrait in the collection of the Georgia Historical Society.

The top photograph shows the intersection of the road to Mulberry Grove and the road going north toward General Anthony Wayne's property. The road to the right leads to Morton Hall, Oakgrove, etc. The bottom photograph was taken looking from the general area of the gate of Mulberry Grove, approximately 100 yards from the house site, and is facing away from the river. Part of this land was at one time called New Settlement and was owned by John Graham.

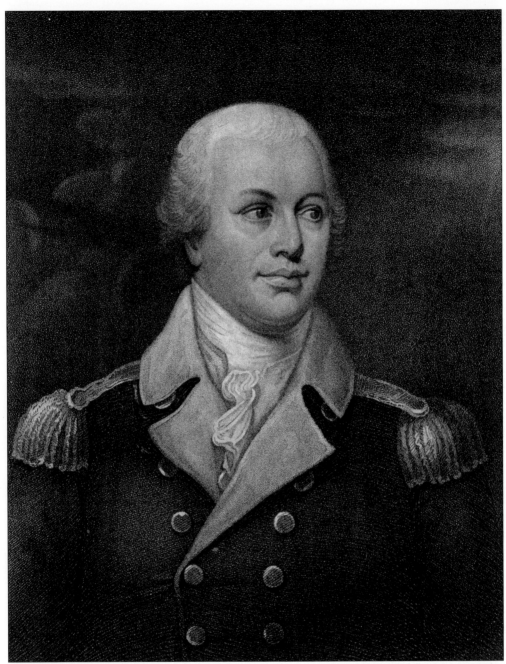

Major General Nathanael Greene was presented with the lands of Mulberry Grove by the state of Georgia following the Revolutionary War. The land had belonged to John Graham, who had fled due to harassment by the patriots. Greene was experiencing financial difficulties and decided to sell his lands and relocate to the Georgia property that had been given to him. Greene died in 1786 and the land was held by his wife for several years.

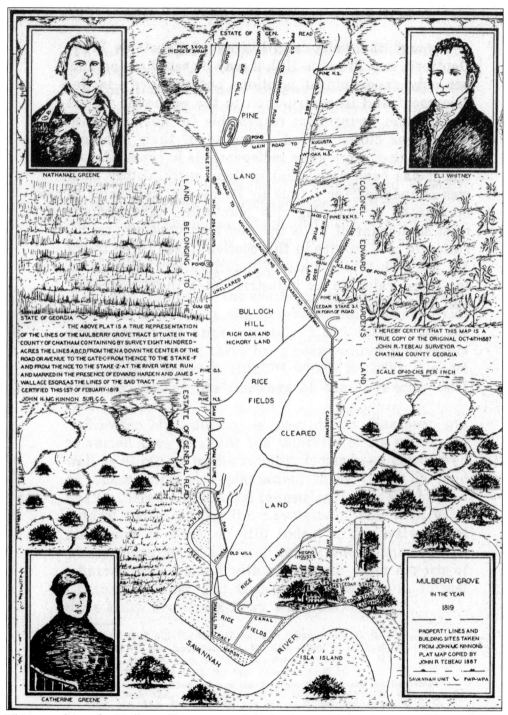

This map shows the Mulberry Grove site and the lands around the plantation. The road from the Augusta Road is shared by the property holders of Mulberry Grove and Richmond Oakgrove. This road is pictured in previous photographs. The Mulberry Grove house sat on the bluff overlooking the river.

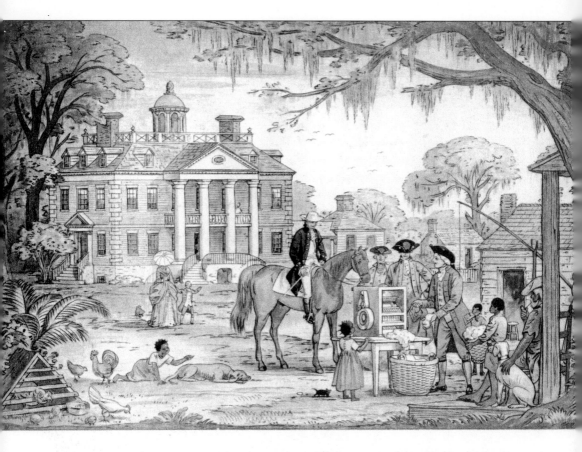

MULBERRY GROVE IN 1794

This is a sensationalized view of Mulberry Grove. Note the cotton gin. In 1794 Caty Greene was still living at Mulberry Grove and in May 1796 she married Phineas Miller. Miller had at one time been a tutor for the Greene children and had become plantation manager. In 1798, experiencing difficulties, including the drowning of George Washington Greene in the Savannah River, the Millers moved with Caty's family to Dungeness on Cumberland Island and attempted to sell Mulberry Grove. She was able to sell the land to Major Edward Harden in August 1800.

This photograph is of the road to Mulberry Grove, looking towards the river. The house site is approximately 100 yards down this road on the right. In this area of the property were the slave quarters. In 1840 Mulberry Grove was purchased by Philip Ulmer. Ulmer was successful in rice production, and upon his death in 1856 his very profitable plantation was sold to Zachariah Winkler.

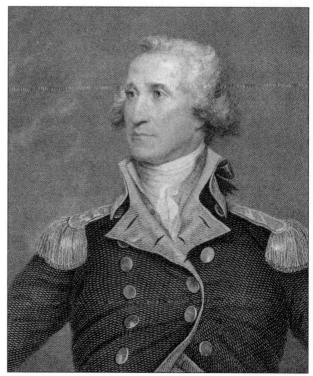

In 1791 General George Washington arrived at Mulberry Grove while on a tour of the South. He was very close friends with General Greene and his wife and made a point of spending time with the widow at Mulberry Grove. Prior to moving to Georgia, Mrs. Greene had been the belle of the social gatherings thrown by Washington during the Revolutionary War. Washington thoroughly enjoyed his time in Savannah and especially Mulberry Grove. His visit was the talk of Savannah.

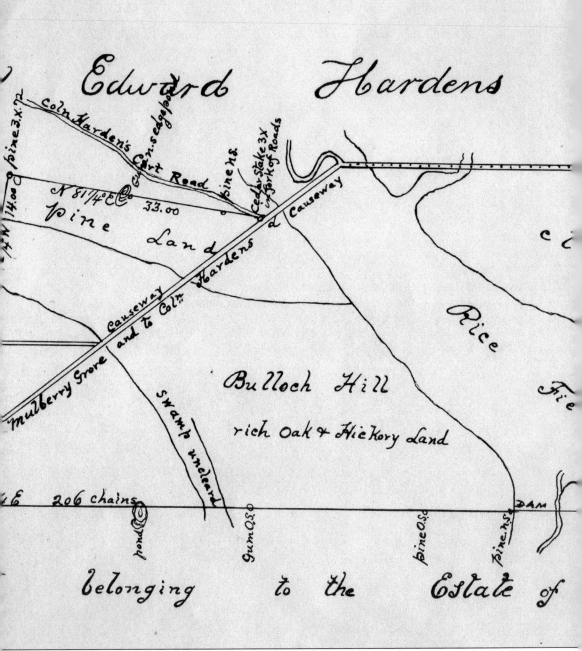

This map, dated 1819 and drawn by John McKinnon, shows Mulberry Grove Plantation. The land was bounded to the north by Edward Harden's Oakgrove Plantation and to the south by

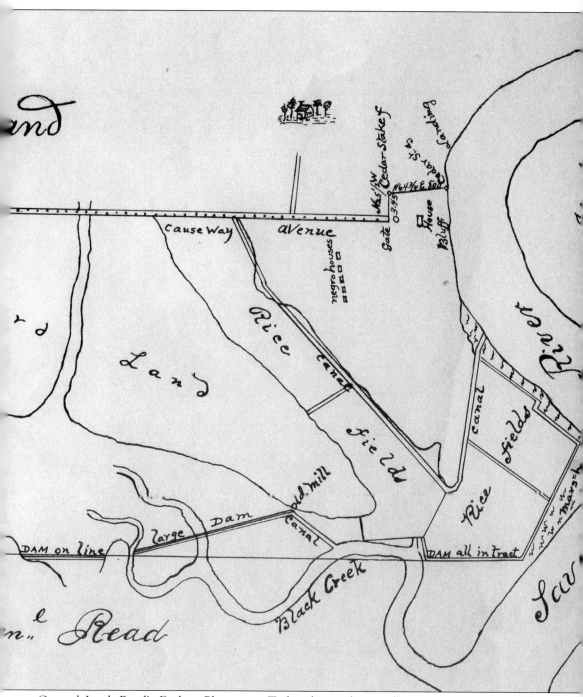

General Jacob Read's Drakies Plantation. Today the road to Mulberry Grove is practically impassable and is owned by the Georgia Ports Authority.

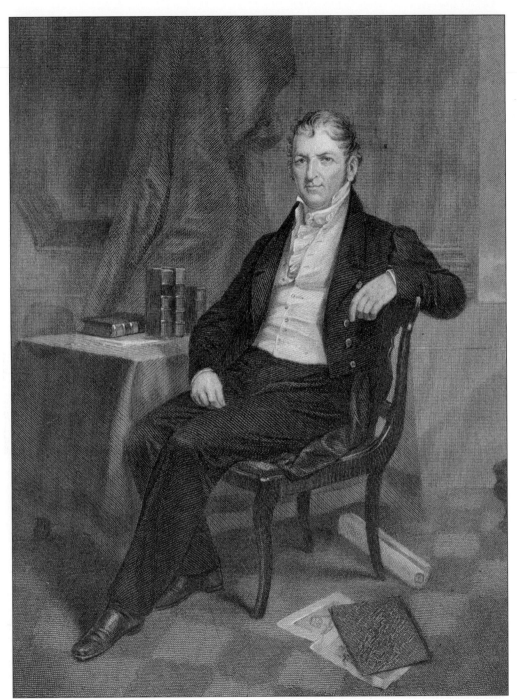

Pictured here is Eli Whitney, inventor of the cotton gin. Whitney was, like the Greenes, a native of Connecticut. He had agreed to come to Mulberry Grove to tutor the Greene children. However, upon hearing the needs of the coastal planters he decided to undertake the development of a better way to prepare cotton for market. Phineas Miller was the financial backer for Whitney's project, which was conducted in an upstairs room of the house. Whitney's invention had a tremendous impact on the South.

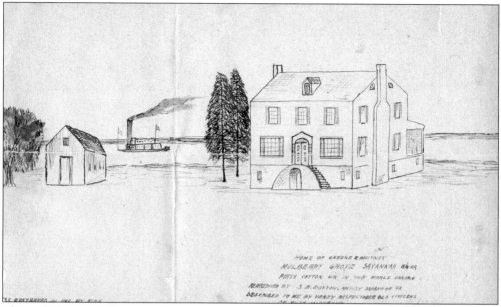

HOME OF GREENE & WHITNEY
MULBERRY GROVE SAVANNAH RIVER
FIRST COTTON GIN IN THE WORLD DRAWN
REDRAWN BY S. B. DAYTON, ARTIST SAVANNAH GA
DESCRIBED TO ME BY VERY RESPECTABLE OLD CITIZENS

This is the only known rendering of the house at Mulberry Grove. When the Greenes arrived at Mulberry Grove the plantation was in a deteriorated state. It had been abandoned and neglected since John Graham fled prior to the Revolutionary War. In a letter written by Greene he stated, "We found the house, situation, and out-buildings, more convenient and pleasing than we expected."

Pictured here are ruins of the foundation of the main house. The house was described as a two-story wooden house on a brick foundation. Greene's description of the house plantation continues, "We have a coach house and stables, a large out kitchen, and a poultry house nearly 50 feet long, and 20 feet wide, parted for different kinds of poultry, with a pigeon-house on the top which will contain not less than a thousand pigeons."

29

With the invention of the cotton gin, Mulberry Grove can be credited with aiding the development of plantations in Georgia. Whitney's gin made production easier and the land suited for cotton more profitable. In addition to its impact on plantations it had a tremendous impact on the infrastructure of Georgia and the South. Cotton was transported down the Savannah River to be loaded onto ships bound for Europe. In addition, the development of railroads in Georgia was fueled by the need to ship cotton faster and improve efficiency.

Three

DRAKIES

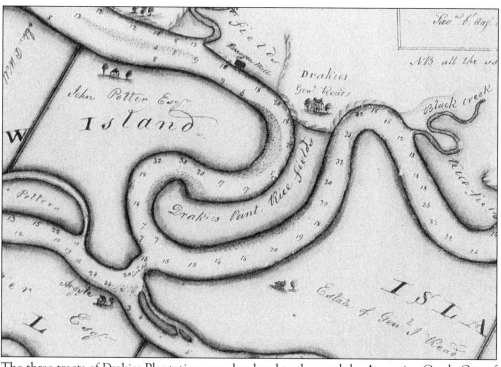

The three tracts of Drakies Plantation were bordered to the north by Augustine Creek. One of the first owners of Drakies was Sir Francis Bathurst. He originally named the plantation Bathurst Bluff. George Cuthbert later changed the name to Drakies. During 1735 and 1736, Bathurst was faced with tragedy. The land that he owned was subjected to numerous floods, and his crops were regularly washed out. He had crops damaged several times by the trustees' horses, which were allowed to roam at large. However, these were not the worst of his problems.

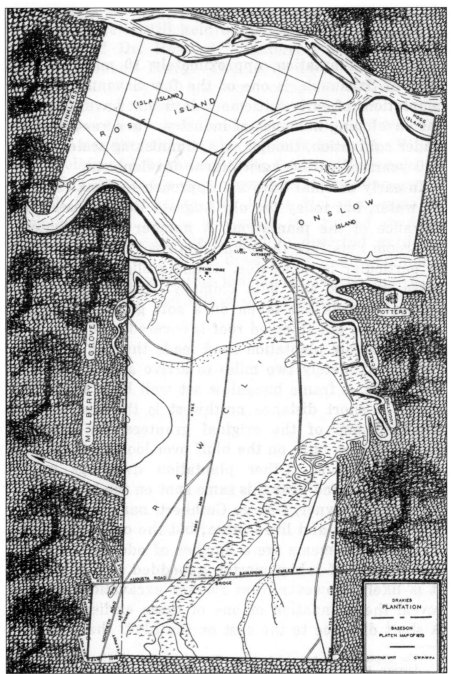

The tragic events that surrounded Sir Francis Bathurst were in some ways impacted by the problems he had maintaining his crops. Bathurst's family was practically starving to death. Lady Bathurst died of what appears to be starvation in April 1736. Two months after his wife's death, Bathurst married a woman wrongly believed to be of substantial means. However, instead of helping his financial situation, she died three months after their wedding and left him with her enormous debt. On September 23, 1736 Bathurst's daughter drowned in the Savannah River, and by the end of 1736 Sir Francis Bathurst died, having withstood more than most.

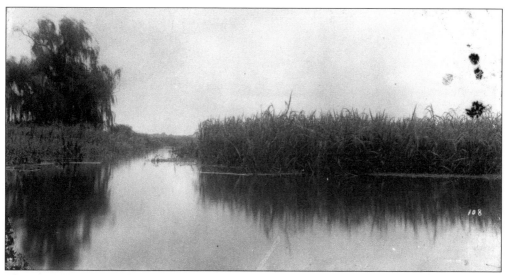

The construction of the rice fields was an extremely labor intensive project. It took a tremendous amount of time to properly construct the fields and prepare them for future planting. One of the most important tasks on the rice plantations was the maintenance of the banks and floodgates. The outside banks followed the course of the river. When the land was cleared and banked, the trees were burned and a 30-foot wide road was constructed. Following the clearing of the land, floodgates or "trunks" were constructed. Even after all of this work, the planter was still at the mercy of the weather, as one severe storm could practically destroy the fields. Both of these images are from the W.E. Wilson Collection, GHS.

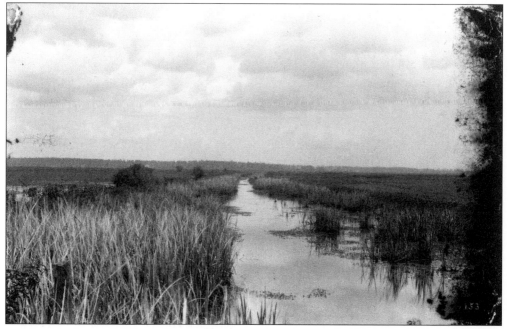

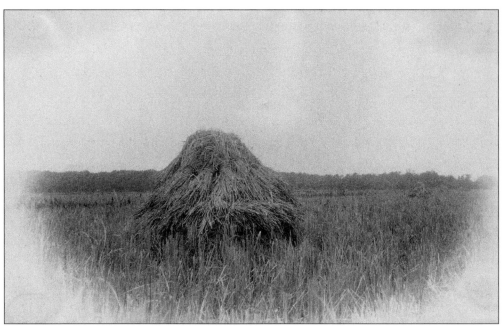

As the rice was harvested it was placed in stacks approximately20 feet long. Rice flats were used in the harvesting of the rice along the larger canals. These canals included the largest ones, which divided plantations, as well as the smaller canals used for drainage and the use of flats. The smallest canals did not allow passage of a flat, and their primary purpose was draining the fields. Many of these canals are still very distinct on the islands in the Savannah River. In a few instances ruins of floodgates and trunks still exist. Both of these photographs are from the W.E. Wilson Collection, GHS.

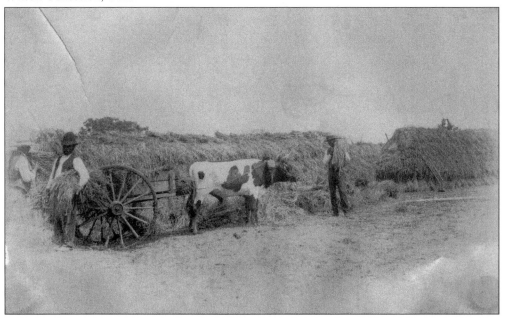

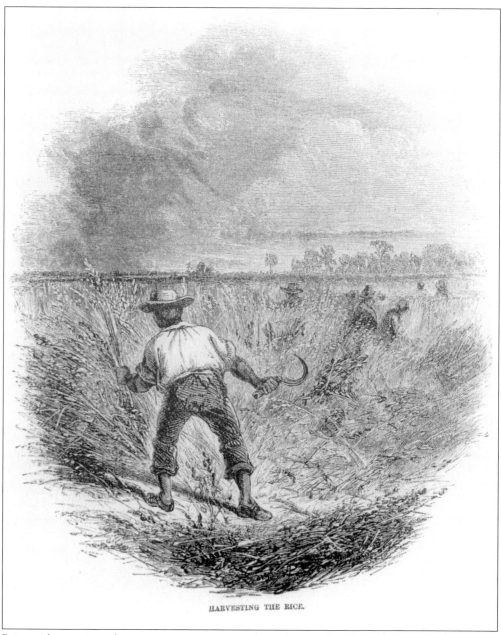

HARVESTING THE RICE.

Prior to harvesting, the rice was given two or three days to dry. Once harvested, the process turned to the threshing of the rice. This was originally done by hand. In the early 19th century a threshing mill was invented, and several began to appear along the Savannah River. Some planters realized a profit from their own harvest as well as through other planters sending sheaves of rice to their mills for processing.

State of Georgia,

Chatham COUNTY.

WARRANTY DEED.

This Indenture, made this, the _Eighth_ _____ day of _March_ _____ in the year of one thousand eight hundred and _Ninty Eight_

between _Geo A Keller_

of the State of _Georgia_ and County of _Chatham_ of the first part,

and _Georgietta Keller, Adarene Warren, Ella Olin, Mattie B Wells, Ida Gilbert, G A Keller, Lamar Keller, Paul Keller, W W Keller, J W Keller, and Gordon Savary,_

of the State of _Georgia_ and County of _Chatham_ of the second part,

WITNESSETH, that the said _Geo A Keller_ of the first part,

for and in consideration of the sum of _Ten_ _____ dollars, to _Him_ in hand paid by the said _Parties_ _____ of the second part, at or before the ensealing and delivery of these presents, the receipt whereof is hereby acknowledged, ha_th_ granted, bargained, sold and conveyed, and by these presents do_th_ grant, bargain, sell and convey unto the said _Parties of Their_ _____ heirs and assigns forever all

that Parcel or Lot of Land in Chatham County State of Georgia Known as the Drakie Plantation on the Savannah River Ten Miles from the City of Savannah Containing about Sixteen Hundred and Ninty acres more or less

Bounded North by the Estate of Winkler
East by the Savannah River
South by the Augustine Creek,
and West by J W Keller and Newton

To Have and to Hold, the said _Parcel or Lot Land_ _____ together with all and singular the rights, members, appurtenances thereto in anywise appertaining or belonging to the only proper use, benefit and behoof of the said _Parties_ of the second part _Their_ heirs and assigns in FEE SIMPLE forever.

And the said _Geo A Keller_ of the first part, will and _His_ heirs, executors and administrators shall the afore granted premises unto said _Parties_ of the second part _their_ heirs, executors, administrators and assigns, forever warrant and defend, by virtue of these presents.

IN WITNESS WHEREOF, the said _Geo A Keller_ of the FIRST part ha_th_ hereunto set _His_ hand and seal the day and year above written.

Signed, sealed and delivered in presence of

W H Exley) _Geo A Keller_ [L. S.]

Van R Winkler) _____ [L. S.]

Apt & off SPEE Ga

In 1866 George Keller purchased Drakies from Henry Rootes Jackson. The rice fields had to be rebuilt, this time without slave labor. Keller was forced to turn to another source. As a result he slowly began planting other crops, and by 1890, truck farming was the major source of income at Drakies. Keller died in 1900 but had left his land to his ten children by his first wife. This document, dated 1898, shows Keller's intentions two years before his death.

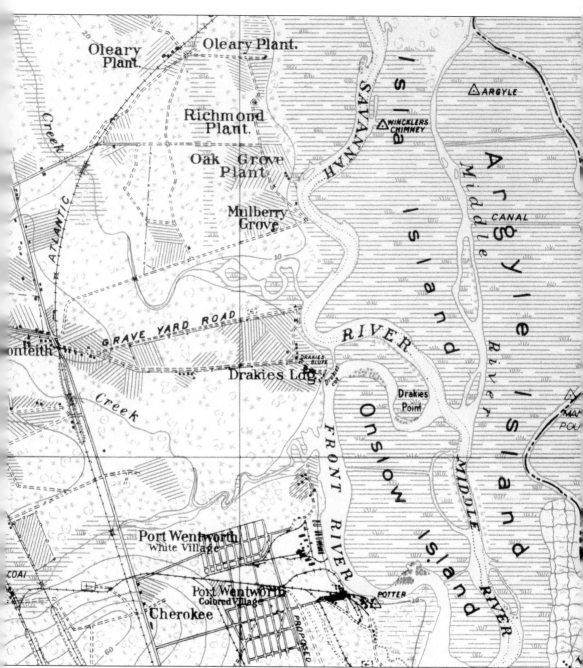

In 1857 Drakies was purchased by John F. Tucker for $25,000. Allegedly Tucker was involved in the illegal slave trade from Africa. The importation of slaves was illegal, and when the *Wanderer* arrived at Jekyll Island the boat was seized and charges were brought against the men involved, including John Tucker. It was determined that insufficient evidence existed to convict the men, and they were all exonerated. Ironically, the United States was represented by District Attorney Henry Rootes Jackson, who by 1871 owned John Tucker's Drakies Plantation. Pictured here is a 1942 map showing Drakies Plantation and the industry to the south.

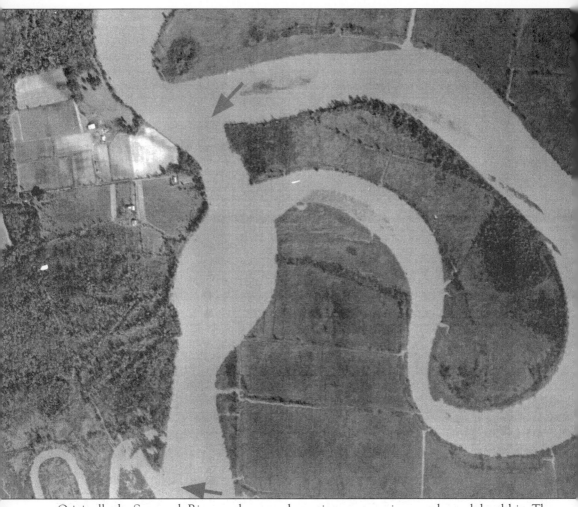

Originally the Savannah River made a very dramatic curve, causing vessels much hardship. The top arrow on this photograph (1953) indicates the area known as McCoombs Cut, sometimes called Drakies Cut. This "canal" was cut following the 1931 easement given to the city of Savannah and eventually the U.S. government. The island created by the creation of the cut was sold to the U.S. government in 1938 to add to the Savannah River Wildlife Refuge. The bottom arrow on the map shows the mouth of Augustine Creek, which was the boundary between Drakies and Coleraine.

Four

COLERAINE

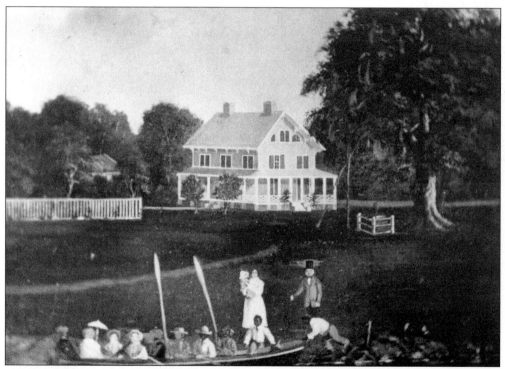

Pictured here is the house at Coleraine Plantation. The original grantees were Cornelius Sandiford, John Williams, Robert Williams, and Patrick Tailfer. Sandiford and the Williamses formed a trading company and used the land as a trading and shipping post. The operation was managed by Robert Williams, who called the land Landiloe. Tailfer's tract was confirmed in 1733, even though Mary Musgrove and her husband already had settled part of the tract they called Cowpen. It would be many years before it was realized that the land was deeded to two people. (Walter Hartridge Collection, GHS.)

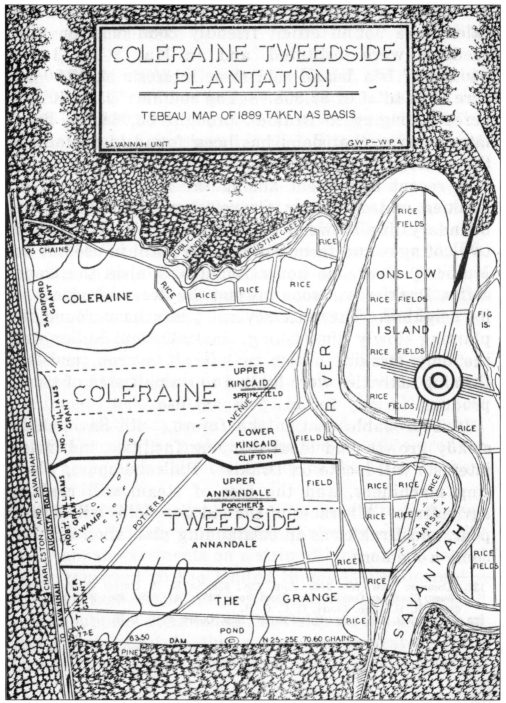

COLERAINE TWEEDSIDE PLANTATION

TEBEAU MAP OF 1889 TAKEN AS BASIS

SAVANNAH UNIT GWP-WPA

Ownership of the Coleraine lands changed extremely rapidly. Numerous crops, including indigo, were tried with limited success. Alexander Wylly, who had acquired the upper portion of land, named the area Coleraine. Upon his death the land went to his son, who sold part of the land, creating new plantations known as Clifton, Springfield, Annandale, and Tweedside. In 1853 the Grange tract was added to the Coleraine holdings.

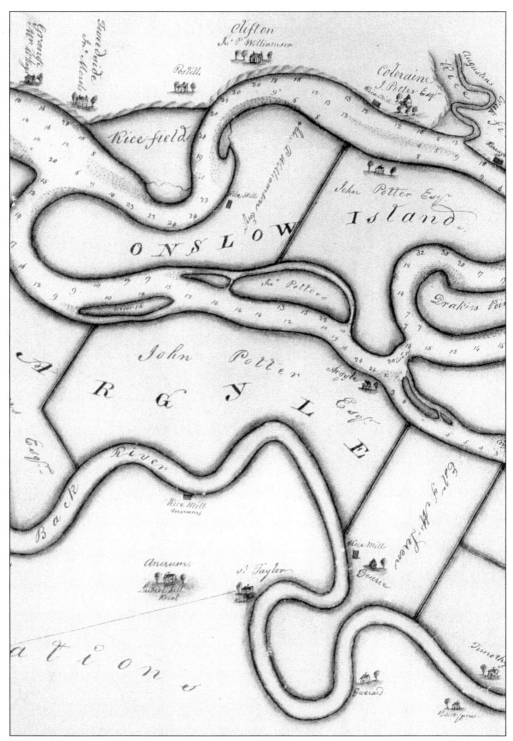

Pictured here is a detail from the McKinnon 1825 Map of the Savannah River (GHS), showing the area from Augustine Creek to Grange Plantation. Note that this map also shows the ownership of the plantation lands on the islands and on the South Carolina side of the river.

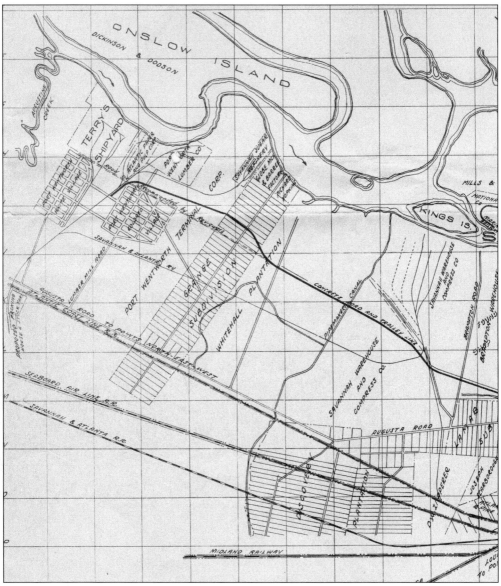

This map from 1919 shows the industry in and around the Coleraine lands. As during the days of the plantations this land was extremely valuable due to its access to the river. By 1853 James Potter had purchased all of the area of Coleraine. He made a profit over the next several years prior to his death in 1862. His land stayed in his family until they began selling parcels in 1899.

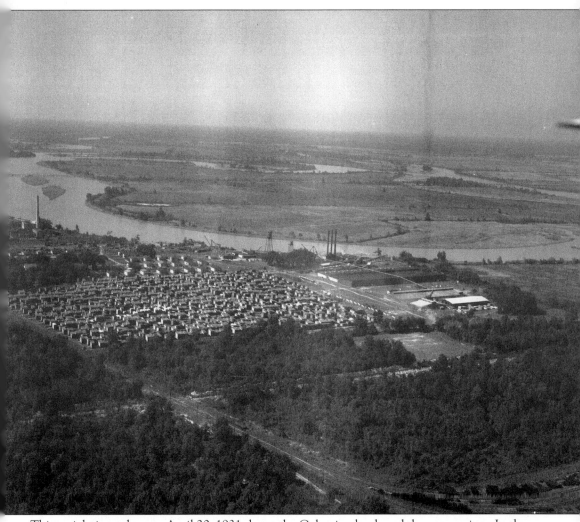

This aerial view taken on April 20, 1931 shows the Coleraine lands and the area upriver. In the distance on the left side of the image can be seen a bridge and two small islands. Approximately 100 yards beyond the bridge is the mouth of Augustine Creek. Beyond that is the cut below the bluff at Drakies. The island shown on page 38 can be seen in the distance.

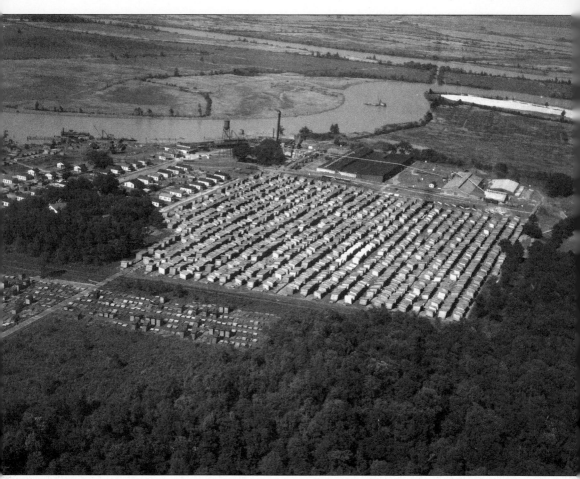

Pictured here is another aerial view of the Coleraine land taken on April 20, 1931. In 1931 this land was owned by the Port Wentworth Company of Massachusetts. In March 1916, the Coleraine lands were sold to the Port Wentworth Terminal Corporation of New York. During WW I the land was in high demand, and one of the first to purchase land was the Savannah Sugar Refining Company. In 1929 the Port Wentworth Corporation of New York transferred their interest to the Port Wentworth Company of Massachusetts, which held Coleraine until 1936.

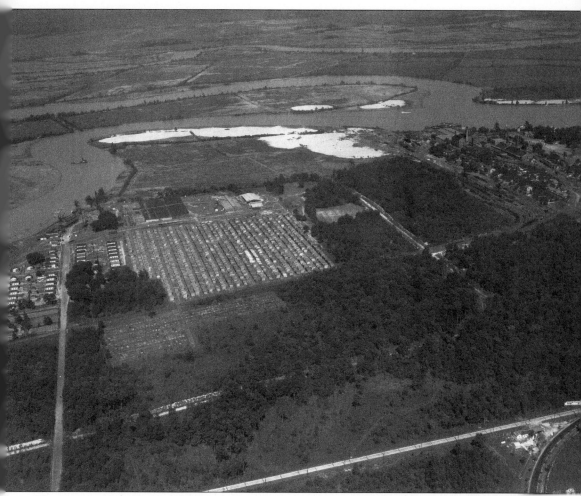

This very interesting view of the Coleraine land was also taken on April 20, 1931. The island in the picture is Onslow Island in the Savannah River. Several years after this photograph was taken, the river's course was altered. Rhodes Cut now runs between the buildings and the area that appears sandy. Just as with the Drakies Cut, the Rhodes Cut helped shipping traffic navigate the river.

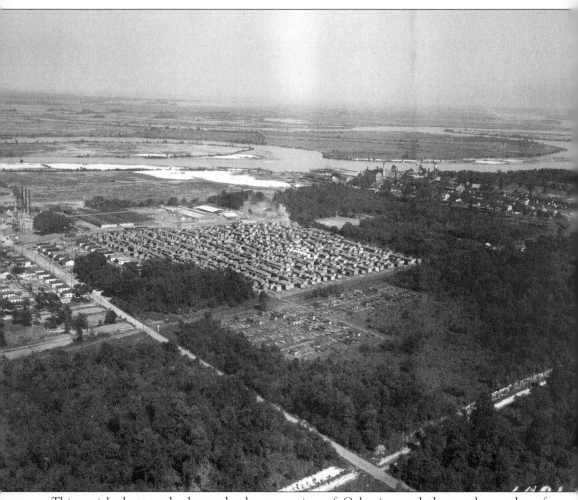

This aerial photograph shows the lower portion of Coleraine and the northern edge of Whitehall Plantation. The area shown is primarily Tweedside and Grange plantations. The Coleraine property has changed through numerous hands within industry, and its owners have included National Gypsum Company, Stone Container Company, Savannah Electric, and Georgia Pacific.

These two photographs that show the Savannah Creosoteing Company were taken in 1932. In 1920 the Savannah Creosoteing Company acquired 21.43 acres from the Port Wentworth Terminal Corporation. The Port Wentworth Corporation had initiated a system of subdivision development to accommodate the labor force and to make the sites more appealing to industry. Two sites were chosen for the subdivision, and these were Bonnybridge and Crossgate.

Some of the industries along the Coleraine tract included Big Stick Lumber Company, Great Eastern Lumber Company, Terry Shipbuilding Company, and Cuban Atlantic Transportation Company. Today the industry along this tract includes Stone Container Company, Georgia Pacific, and Dixie Crystal. These photographs were taken on May 31, 1998.

This view of the Coleraine lands and the Stone Container Company was taken on May 31, 1998, looking down the Savannah River from the Houlihan Bridge. The original Port Wentworth Terminal Corporation was created in conjunction with the Savannah and Atlanta Railroad. By the 1920s, the company and railroad were experiencing severe financial difficulties. Richard M. Nelson is credited by many with leading the railroad into the black by 1939. Upon his retirement in 1950, the Savannah and Atlanta Railroad was operated by the Central of Georgia Railroad as a subsidiary.

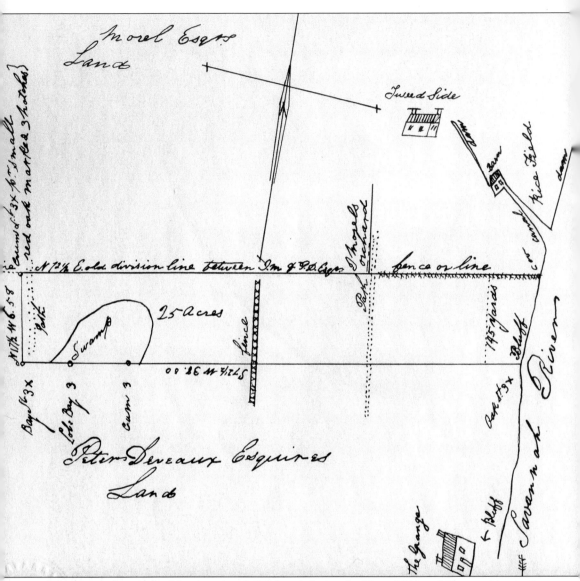

This survey from a deed book is dated 1795 and shows the Tweedside and Grange houses. In 1857 James Potter purchased Tweedside Plantation. There was speculation that he would combine the slaves and efforts of the two plantations into one massive operation. However, Potter decided to maintain Tweedside and its numerous slaves as he felt it would prove more profitable. Potter decided to build himself a grand house on Coleraine. The house was completed around the time of the acquisition of Tweedside. Louis Manigault described the house as "Superior to any on the River . . . "

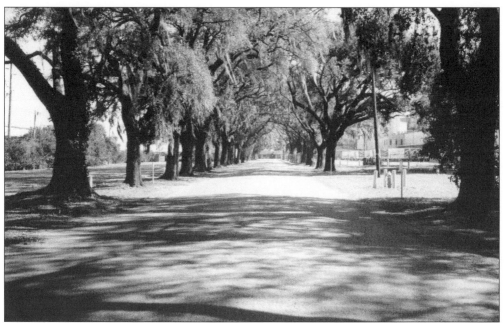

This oak-lined road is Oxnard Avenue. This area was Tweedside Plantation and is currently owned by Dixie Crystal (formerly Savannah Sugar Refining Corporation). The photograph pictured on the bottom of this page is of the area where the house stood. The Tweedside Plantation house was located approximately where the tree is located in this picture. The Savannah Sugar Refining Company increased their original holdings, which they purchased in 1916, with an additional purchase of 80.6 acres in 1918.

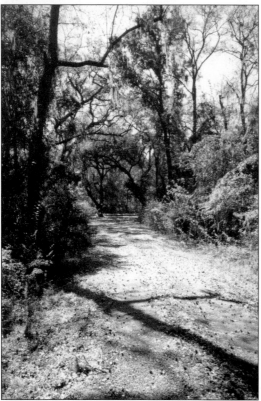

The area surrounded by the trees was the site of Grange Plantation. The tract that became Grange Plantation was originally granted to both Patrick Tailfer and John Musgrove simultaneously. Following the Revolutionary War it was conveyed to Peter Deveaux by the Commissioners on Confiscated Lands. Deveaux had very few slaves, and it is doubtful that he made a profit with the land. In 1813 Deveaux sold the Grange lands to Robert Mackay. Mackay died in 1817 and Eliza, his widow, managed the plantation, eventually selling the Grange lands to William Washington Gordon for $500 in 1832.

These two photographs are of the eastern edge of the Grange land, one looking toward and one looking away from the river. This area is covered by an oak forest and has not experienced much development. The western edge of the Grange land consists of wetlands. In addition, the western area has been altered in a variety of ways due to industrial development. Part of the Grange tract was developed as Grange Subdivision. Currently there are 23 houses remaining as part of Grange Subdivision.

General Land Use Plan

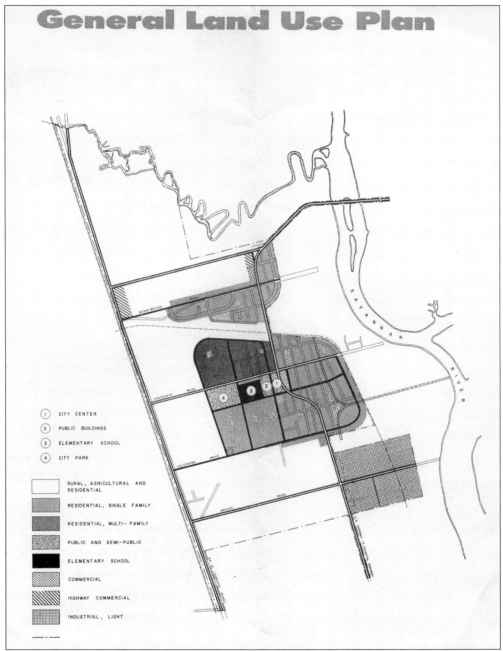

- (1) CITY CENTER
- (2) PUBLIC BUILDINGS
- (3) ELEMENTARY SCHOOL
- (4) CITY PARK

RURAL, AGRICULTURAL AND RESIDENTIAL

RESIDENTIAL, SINGLE FAMILY

RESIDENTIAL, MULTI– FAMILY

PUBLIC AND SEMI–PUBLIC

ELEMENTARY SCHOOL

COMMERCIAL

HIGHWAY COMMERCIAL

INDUSTRIAL, LIGHT

This Land Use Plan by the Port Wentworth Planning Commission was completed in 1959. Port Wentworth was incorporated as a city on February 6, 1957. On this map, the Houlihan Bridge connecting Georgia and South Carolina can be seen. Upriver from the bridge is the mouth of Augustine Creek, which was the boundary between Drakies Plantation and Coleraine Plantation. Augustine Creek is named for Walter Augustine, who settled part of the Drakies land at the same time as Sir Francis Bathurst and who deemed agricultural pursuits as secondary to the lumber industry. Since 1959 there has been much industrial growth into the areas indicated on this map as "Rural, Agricultural, and Residential."

Five

WHITEHALL

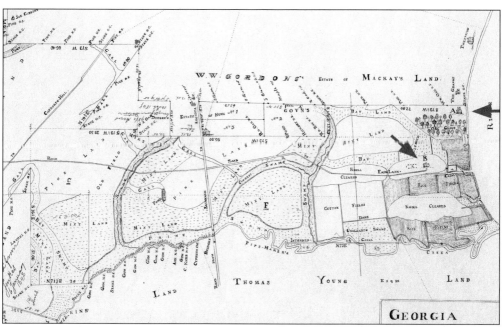

Whitehall Plantation was composed of several smaller tracts that were brought together under the ownership of Thomas Gibbons. The original tracts that eventually made up this plantation were Whitehall, Fairlawn, Pine Land, Orange Valley (or Caton), Shaftsbury, and Mansfield. Joseph Gibbons received the original grant of the northernmost tract which bordered Grange. This map shows the tract in 1830. The arrow farthest to the right shows the Whitehall Plantation house. The other arrow shows the location of Fairlawn Plantation. This area is currently owned by the Georgia Ports Authority.

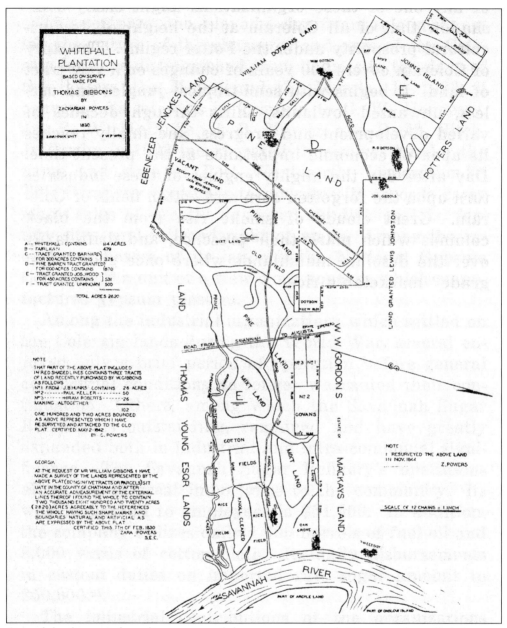

One of the first people to live on one of the tracts was Joseph Watson, who called the area Grantham Town. In 1755 Watson sold his land to William Francis. Upon the death of Francis the land was gradually sold off to Basil Cowper, Edward Telfair, and Isaac Young.

In 1796 Thomas Gibbons purchased Grantham Town and changed the name to Fairlawn. Through his brother's holdings, they now owned one unbroken mile of valuable riverfront. Pictured at right is Thomas Gibbons, from an image at the Georgia Historical Society.

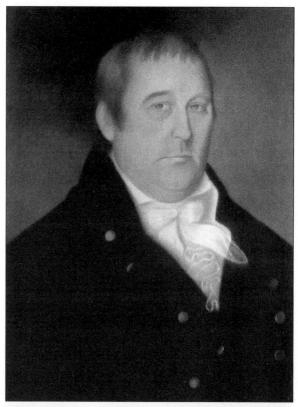

The land owned by Joseph and Thomas Gibbons was bequeathed to William Gibbons, son of Thomas. He made several major improvements to the land but did not focus his effort extensively on the house. William Gibbons died in 1852 and the bulk of this massive property went to his son, William Heyward Gibbons. Pictured below is the house at Whitehall Plantation, built following the Civil War, in a photograph taken c. 1910. This image appeared in a book promoting Savannah that was developed in 1911 by the Chamber of Commerce.

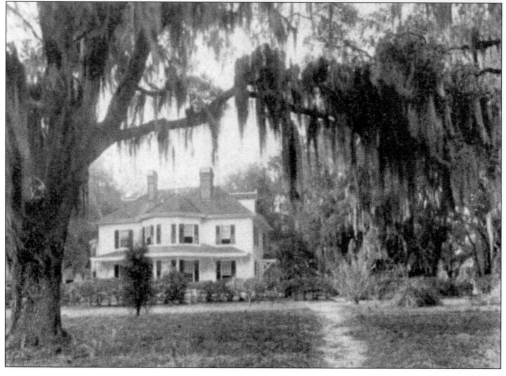

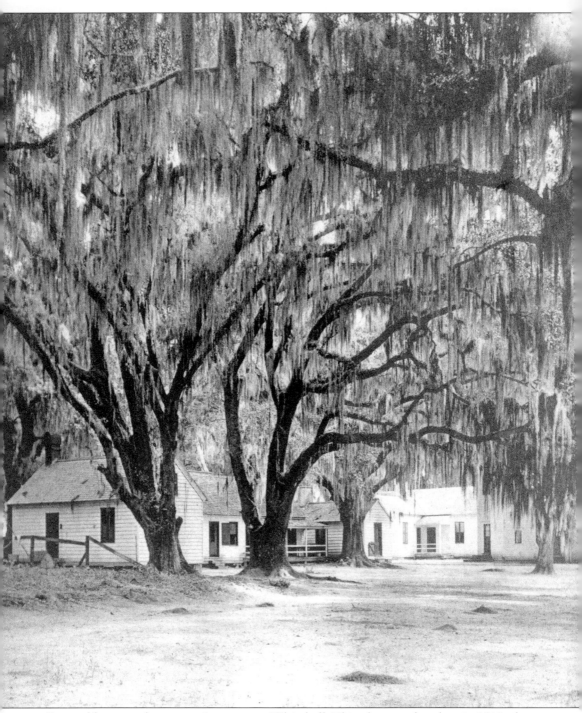

Pictured here are the servants' quarters at Whitehall. This photograph, taken in 1910, shows improvements and additions that were made. Following the Civil War, free slaves led by Abalod Shigg claimed Whitehall and Fairlawn plantations as theirs. They used the argument that they were to receive "40 acres and a mule." Federal soldiers were placed on the property to prevent an uprising of the former slaves.

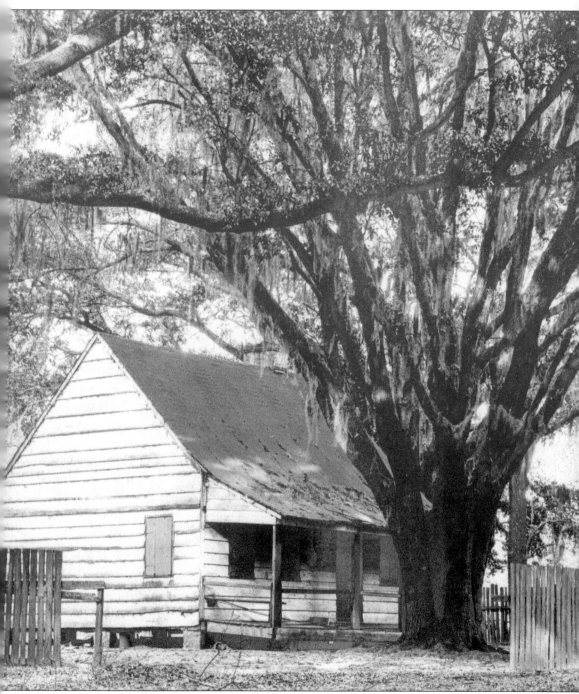

This 1910 photograph is identified as the overseer's house. This house was rebuilt following the Civil War. While the Federal soldiers were encamped at Whitehall to prevent an uprising of the former slaves, they stripped the boards from the house and used them for fires. During the Civil War, Whitehall Plantation suffered the fate of the other plantations along the Savannah River. In the War, William Heyward Gibbons joined the Confederate Army and was soon promoted to Major.

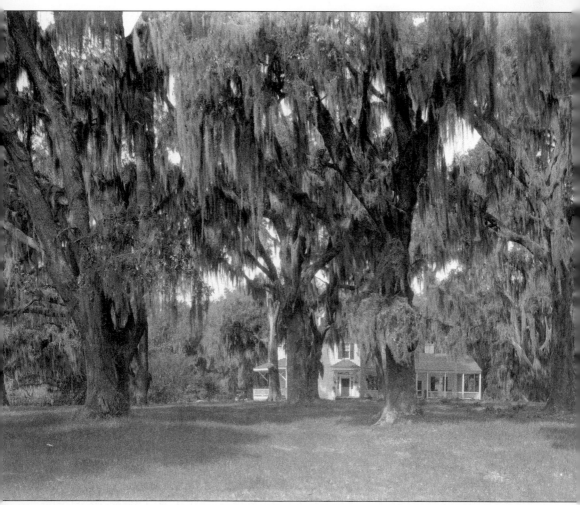

At the time of his father's death, William Heyward Gibbons was 23 years old. The family had split their time between Savannah and New England. William Heyward looked fondly upon Savannah and Coastal Georgia and selected the area as his home. He purchased a house in Savannah that had been purchased by Major Alfred Lamar Hartridge. The house, which was located at the intersection of Abercorn and Huntingdon Streets, was to be his main residence. The house at Whitehall was little more than a lodge, and was destroyed during the Civil War.

William Heyward Gibbons continued the tradition set by his father and grandfather in large-scale planting. In 1851 his father conveyed to William a plantation consisting of 10,640 acres on the Savannah River in Screven County. Along with the land, the young William received 71 slaves and all equipment and machinery that was on the property. These two 1910 photographs show additional views of the Whitehall house. It is believed that the area selected by Gibbons for his "lodge," and the eventual location of the house that stood into the 1960s was the area where Mary Musgrove constructed her house on her land called Cowpen.

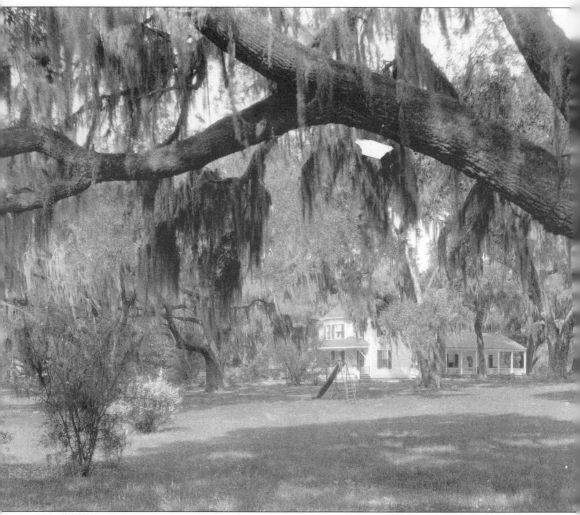

After the Civil War, William Heyward Gibbons could not immediately return to his land, due to the dispute and claims of the former slaves. Eventually, he was able to return to his ruined plantation. Luckily, Gibbons was a shrewd businessman and possessed the means to rebound quickly. The largest expense for Gibbons following his re-establishment was labor. Gibbons was forced to hire ditchers to reconstruct the rice fields beginning on Argyle Island. Eventually he turned to Irish labor hired from the North that were used for repair to the fields as well as planting and harvesting. The first Irish workers on Whitehall probably arrived in 1871.

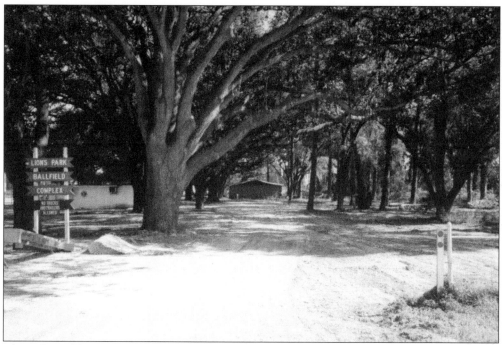

The only visible remaining indication of Whitehall Plantation is a very short piece of the oak-lined road, seen here from the highway. These trees are part of the road that is now a baseball field and complex. The bottom photograph shows the end of what is left of the tree-lined road. In the background can be seen the property of the Georgia Ports Authority. These photographs were taken on February 25, 1998.

In the general area beyond the water tower is the site where the Whitehall house stood. The trees in the distance are part of the woods remaining from Grange Plantation. Although it is difficult to see from these two photographs, the Whitehall house site was very close to the river. These photographs were taken on February 25, 1998.

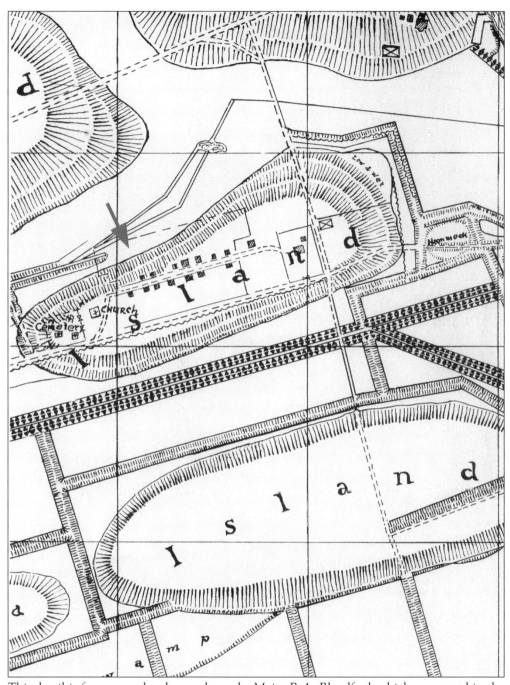

This detail is from an undated map, drawn by Major R.A. Blandford, which was traced in the county engineer's office by members of the Savannah Unit of the Georgia Writers Project. The area shown is Fairlawn Plantation, which was part of Whitehall Plantation and is currently owned by the Georgia Ports Authority. The arrow is pointing toward a row of houses that were slave quarters. The Fairlawn property was purchased in 1795 by Thomas Gibbons from Isaac Young. At the time it was known as Grantham.

Pictured here is the cemetery on Fairlawn Plantation. The cemetery was used by slaves living on the plantation. Almost all of the markers in the cemetery are from 20th-century deaths. However, it is evident that there are numerous unmarked graves covering the entire area and dating back almost 200 years. The top photograph shows the original road, which is still used and curves to the area where the slave quarters stood.

In 1878 a church was built on the land for the free slaves living on the property for a cost of $351.66. In 1879 Gibbons hired a new overseer named C.A.J. Sweat. Sweat lived in the rebuilt house on Fairlawn. Both of these photographs were taken on February 25, 1998. The first photograph shows what may have been part of a fence, and the bottom photograph shows a cut stone in the general area of the church. This could possibly be part of a grave as this is very close to the cemetery, or it could be part of a foundation. On February 14, 1919, the church and slave quarters at Fairlawn were destroyed by fire. Both of these pictures were taken on the property currently owned by the Georgia Ports Authority.

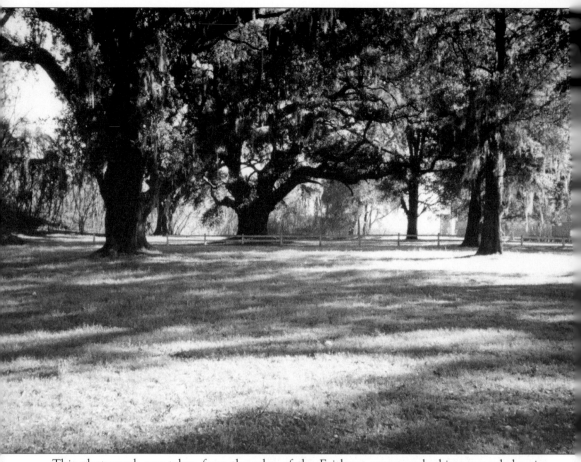

This photograph was taken from the edge of the Fairlawn cemetery looking toward the site where the church stood. The previous two photographs were also taken in this area. The Gibbons family managed this and all Whitehall land into the 20th century. They sold the land to Richard Hopkins, president of the National Rosin Oil and Size Company of Savannah. Whitehall Plantation was the last plantation on the Savannah River used as a private residence. It is now part of the Georgia Ports Authority.

Six

IRENE MOUND

This 1953 aerial view shows Pipemaker's Creek, which divides Whitehall Plantation and Rae's Hall Plantation. Pipemaker Creek, originally having many curves, was straightened in 1834 by slaves belonging to William Gibbons. The creek became known as Pipemaker's Canal and was heavily used to bring rice, lumber, and many other products to the Savannah River. At the mouth of Pipemaker's Canal is Irene Mound. This area has a very interesting history.

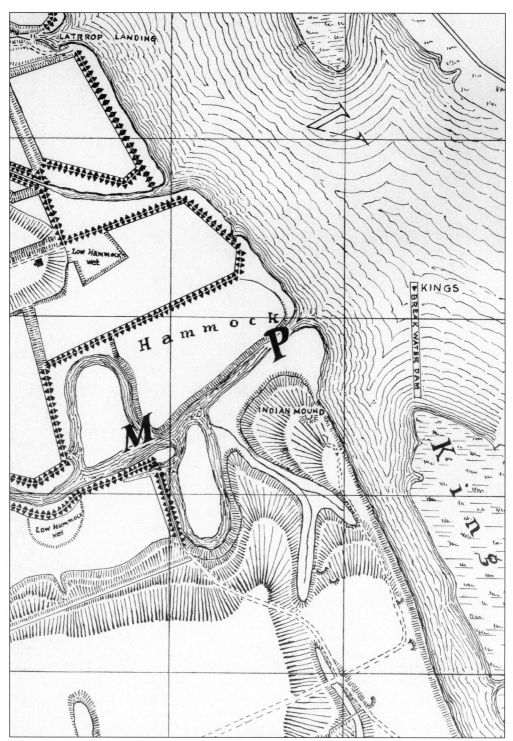

This detail is from an undated map drawn by Major R.A. Blandford showing the area where the mound was positioned. This area was called New Yamacraw, and it is the same site where the Moravians built a school in the 1730s. The school ceased operation by 1737.

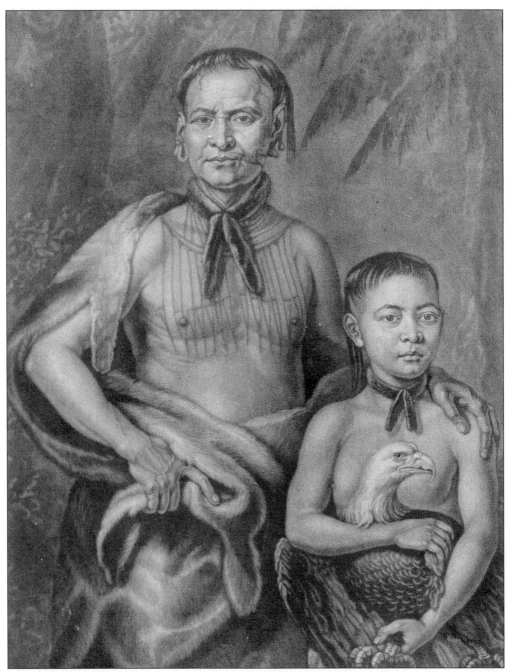

Upon the arrival of Oglethorpe and the colonists, they discovered an Indian village upon the present site of Savannah. In May 1733 the Yamacraw Indians agreed to move farther upriver and give their current site to the English. The area where the Indians moved was called New Yamacraw. Pictured here is Tomochichi, King of the Yamacraw, and his nephew.

In the 1930s Dolores Boisfeuillet Colquitt Floyd established the fact that the Moravian school had stood on Irene Mound. She also raised awareness about Irene Mound, and after she went public with her research a Works Project Administration project was initiated. Archaeological work on Irene Mound began on September 11, 1937. Mrs. Floyd is pictured here standing on top of Irene Mound.

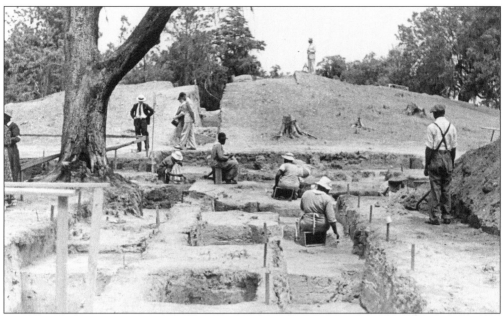

When excavation of the mound began, the archaeologists discovered three levels, each containing numerous Indian artifacts. Peter Rose was part of the original group of Moravians that came to the new colony. Catherine Freidel came with the second group of Moravians to join her husband Friedrich, who unknown to her had died while she was on her voyage. She married Peter Rose and the two of them worked long hours operating the little school on Irene Mound. By 1739, Rose and his wife moved back to Savannah and eventually moved to Germantown, Pennsylvania to live in a Moravian settlement.

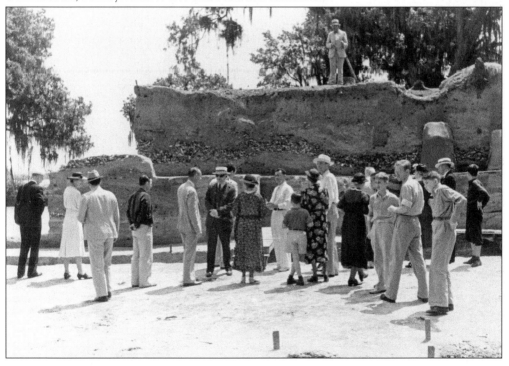

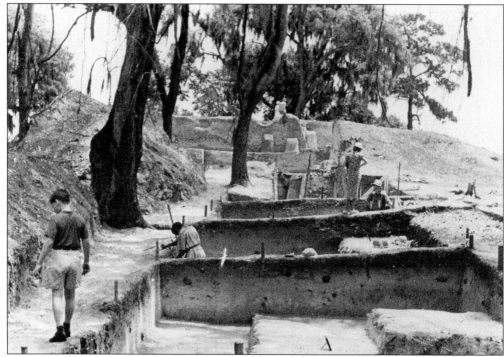

In the early 19th century it was apparently forgotten that Irene Mound was significant to the Indians, who were no longer living in the area. Court records documenting property transactions refer to the mound as "a large Mount just by the mouth of Pipemaker's Creek and very near the Savannah River . . . almost as high as the bluff at Savannah and is indeed very remarkable, by the large growth of live oak thereon." Pictured here is the mound site during excavation.

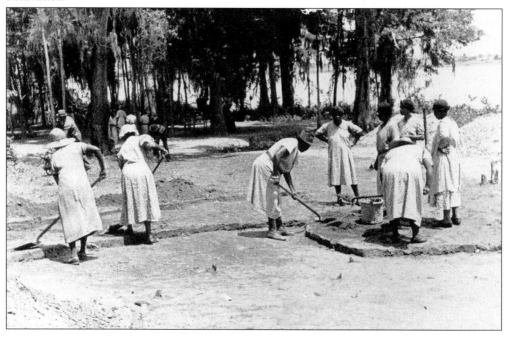

The Rae Family, owners of Rae's Hall Plantation, felt that the mound was a wonderful family burial ground. Several family members were buried in the mound, including General Samuel Elbert, son-in-law of John Rae. Markers were placed at the graves, but after the land passed through several owners the burial ground was forgotten and the markers disappeared. In the 1920s a group of Savannahians were successful in locating and removing the remains of General Elbert. His remains were moved to Colonial Cemetery in Savannah. However, the significance of Irene Mound as an Indian site was still overlooked. These two pictures were taken when the Georgia Archaeological Society visited the site. The remains shown in the bottom photograph are not those of General Elbert. He had been resting in Colonial Cemetery for approximately 15 years when excavation began.

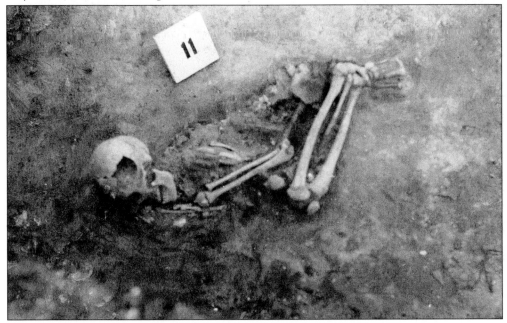

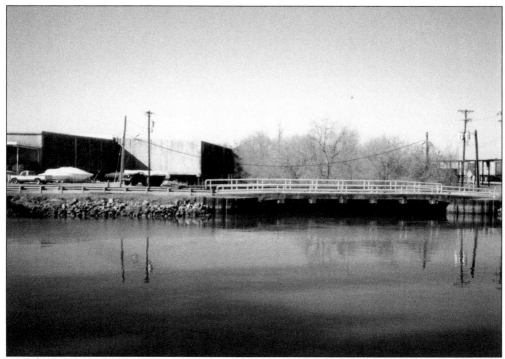

These two photographs taken on February 25, 1998 are of the Irene Mound site. On the right-hand side of both photographs is the mouth of Pipemaker's Canal. The mound was extremely large and covered the area downriver from the mouth of the canal. Currently this land is owned by the Georgia Ports Authority.

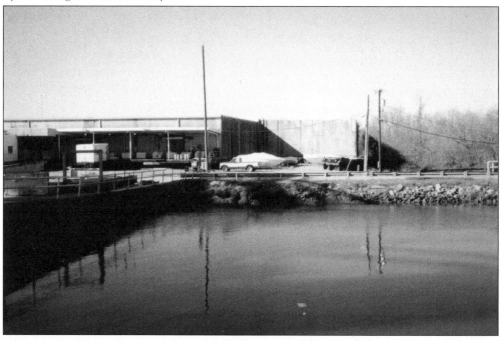

Seven

RAE'S HALL

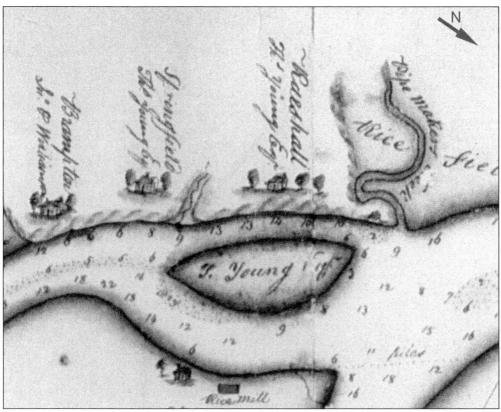

The land that became known as Rae's Hall was originally part of the land disputed by Mary Musgrove. She claimed that this land belonged to her through an agreement she had worked out with the Yamacraw Indians. She was the daughter of a Scottish trader and an Indian mother. Oglethorpe used her extensively as an interpreter, and she proved extremely valuable during negotiations with the Indians. She eventually moved to St. Catherines Island. This detail is from the 1825 Savannah River map drawn by John McKinnon.

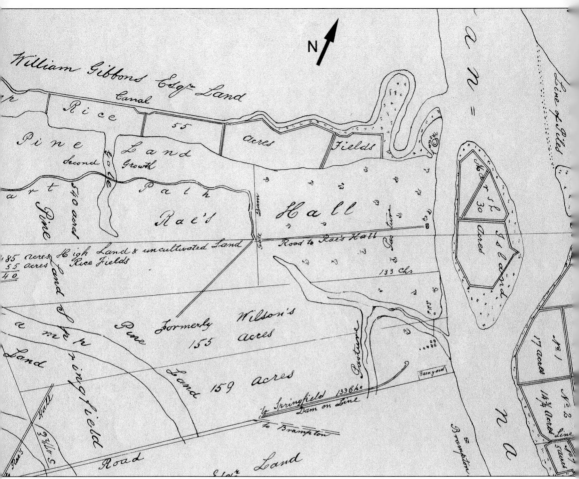

This map was drawn in January 1838 by C. Stephens. After Mary Musgrove left the area it was settled by Patrick and David Graham. They called the land Redford, and by 1760 all of the land had passed through several hands and was purchased by John Rae, an Augusta merchant. He sold some of the land to Jonathan Bryan and Isaac Young, but the bulk of the property remained in Rae family hands. At the close of the 18th century the land was purchased by Thomas Young.

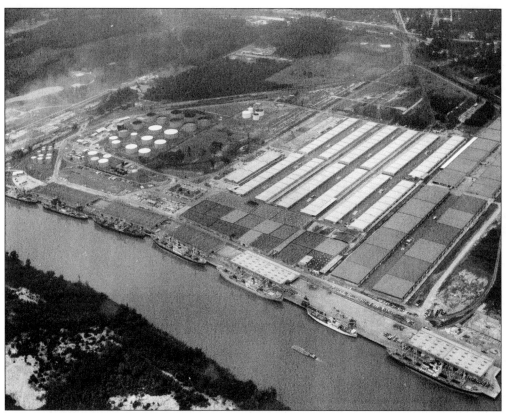

This 1970 photograph is an aerial view of Rae's Hall under its current use by the Georgia Ports Authority. In the bottom right corner, the mouth of Pipemaker's Canal can barely be seen. Irene Mound stood approximately 100 yards downriver of Pipemaker's Canal. Some of the higher ground of the mound can be seen in the bottom right corner.

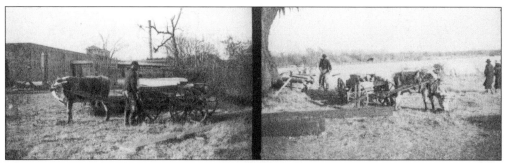

This image, from the Floyd Papers at the Georgia Historical Society, was taken in January 1938. The two women seen on the right are Mary Floyd and Bessie Lewis. Mrs. Floyd labeled the photograph as being taken east of the fence of the Savannah Warehouse and Compress Company.

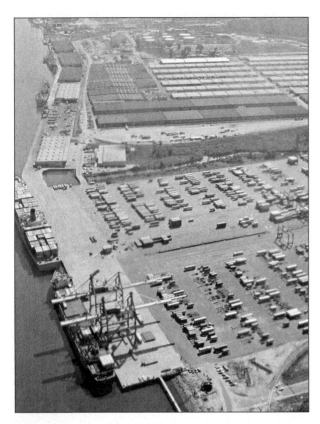

This aerial view from 1975 was taken looking downriver. This image provides a wonderful view of the industry along Whitehall Plantation, Pipemaker's Canal, and Rae's Hall. All of this land is owned by the Georgia Ports Authority.

Cranes were constructed along the river on the Georgia Port Authority land. Of particular note in this picture is Pipemaker's Canal. The mouth of the canal can be seen between the photographer and the crane.

Rae's Hall was owned by several people following Thomas Young. It was acquired in 1834 by Mitchell King of Charleston. It ceased operation as an agricultural unit during the Civil War and upon King's death. The King family owned the land until they began selling parcels in 1872. Pictured here is Mitchell King, son of the man who purchased the land in 1834.

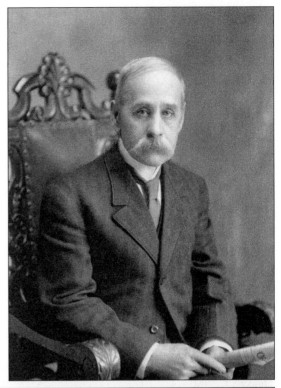

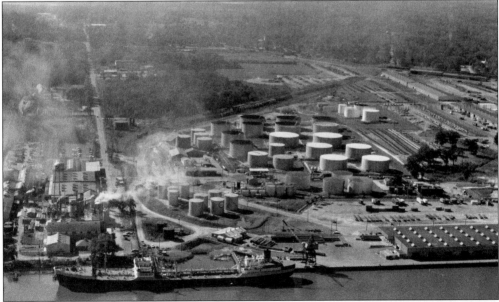

In 1865 Rae's Hall Plantation belonged to the Freedman's Bureau. Free blacks lived on and farmed the land. The Kings also lived on the property and in 1872 began selling parcels of the land. The land went through several hands until 1916, when it was purchased by the Savannah Warehouse and Compress Company. This photograph, taken in the 1970s, shows the area of Rae's Hall farthest downriver. The tanks in the center of the photograph are part of Southland Oil.

These two photographs were taken on February 25, 1998. This is the approximate site of the Rae's Hall Plantation house. In keeping with the name of the plantation, one of the buildings currently operated by the Georgia Ports Authority, and probably built in the 1970s, is called Rae's Hall. The building built by the Ports Authority is not on the same site as the plantation house.

Eight
BRAMPTON

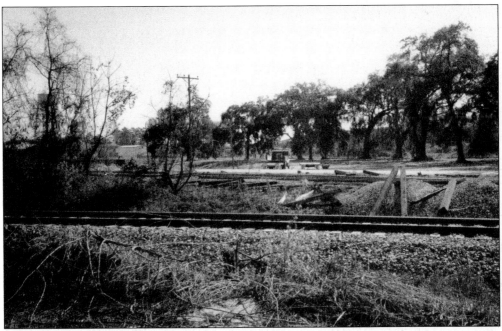

The area which later made up Brampton Plantation was owned by the Indians from the founding of the colony until 1757. The land passed though several hands until finally being acquired by Jonathan Bryan in 1765. Bryan owned several plantations but his favorite place was the area that he named Brampton. Pictured here are trees that line the former road to the plantation. This photograph was taken in February 1998.

These two photographs were taken in February 1998, from the center of the oak-lined road to the plantation. The top photograph was taken looking toward the Savannah River, and the bottom photograph was taken from the same spot but facing the opposite direction. The land is currently the property of the National Gypsum Company.

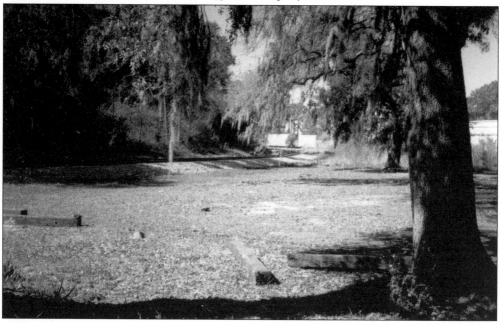

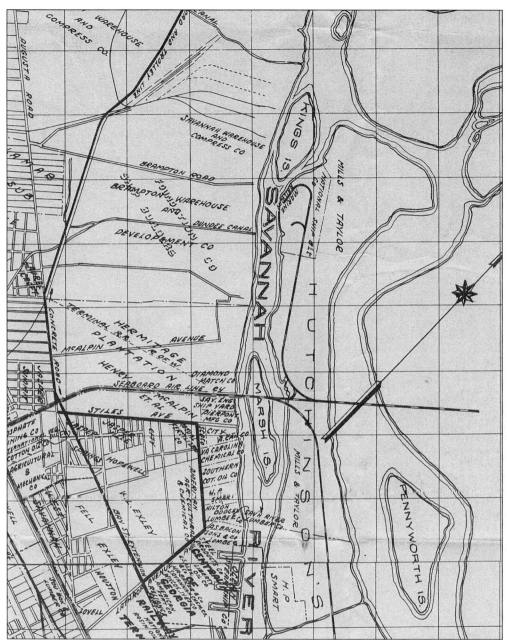

This map of the Savannah River, drawn in 1919 by W.F. Shellman, shows the industry that has consumed some of the plantation sites. The Brampton property was owned at the time of the drawing of this map by the Brampton Warehouse and Development Company. Notice Dundee Canal reaching the river near the "V" in Savannah. Dundee Canal was constructed in the 1890s as a drainage canal. It was not intended for navigation and was to be used as a drainage canal for the Savannah and Ogeechee Canal.

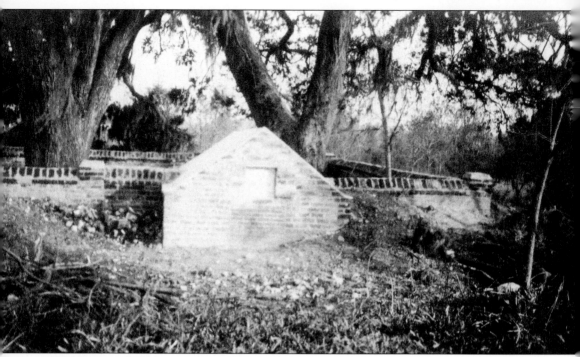

This photograph of the cemetery at Brampton was taken in the early 20th century. In addition to the Bryan Family, members of the family of John G. Williamson are also buried in the cemetery. Jonathan Bryan and his wife were both buried within the crypt, while the other family members were buried within the walls of the cemetery. During the Civil War Union soldiers raided the grave of Jonathan Bryan, looking for valuables they believed were hidden by the locals.

Jonathan Bryan was a patriot and considered a notorious ringleader of rebellion. He was active in events leading up to the Revolutionary War and at the age of 74 participated in the fighting around Savannah. He and his son were captured and imprisoned on Long Island. By the time the Bryans returned from New York Jonathan's wife had died. These two photographs of the cemetery were taken in March 1998. The trees seen on the previous photograph have died and been removed. The cemetery is maintained by employees of the National Gypsum Company. This cemetery is on private property.

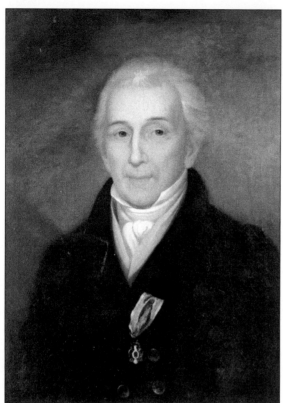

One of the early tracts that eventually became part of Brampton Plantation was Blendon Hall. This area was originally established by Samuel Barker. It was sold to Pickering Robinson and then to John Wereat (pictured here). Wereat held the property for nine years and then sold the land for four times what he paid.

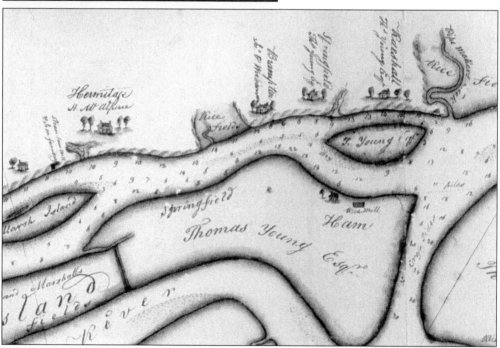

This map, drawn by John McKinnon in 1825, shows Brampton Plantation and the surrounding land. Brampton Plantation is in the center of this detail.

Jonathan Bryan was extremely concerned with the lives of his slaves. He encouraged them to hold religious services which were eventually held in the barns at Brampton Plantation. The preacher for the slaves was Andrew Bryan, also a slave. For a short period the services were held closer to Savannah and included slaves from other plantations. Fearing an uprising, the citizens of Savannah forced the services back to Brampton. Out of this church came two churches. The top photograph, taken about 1875, is of the First African Baptist Church on Franklin Square. The bottom photograph is of the First Bryan Baptist Church in Savannah.

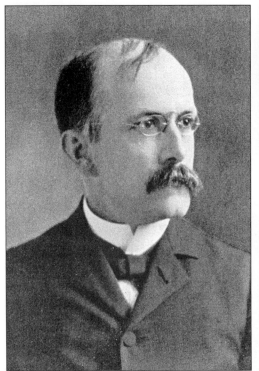

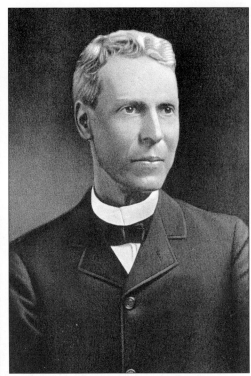

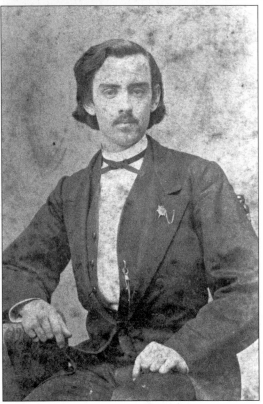

During the Civil War the buildings at Brampton were burned. In 1867 the land was sold to Dr. James Bond Read of Savannah. Read did not rebuild and the plantation never again had a permanent residence. However, Brampton Plantation has the distinction of being the site of the last two duels in Savannah. The last fatal duel occurred in 1870 on this property. In 1877 a duel between Samuel Barnard Adams (top left) and Rodolph Rufus Richards (top right) occurred on Brampton. Their seconds were Peter W. Meldrim (bottom left) and Edward C. Hollis (died 1879). No one was injured, honor was restored, and everyone except Hollis had magnificent careers.

Nine

HERMITAGE

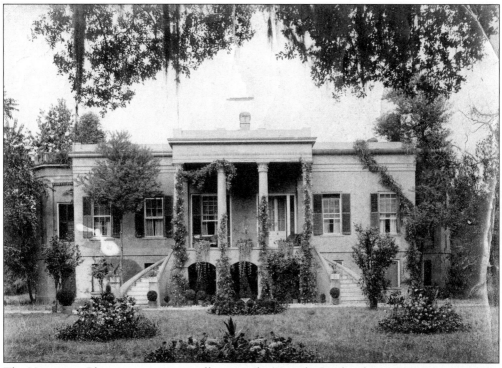

The Hermitage Plantation was originally granted to Joseph Ottolenghe in 1750. He named the plantation Exon. He sold the property to William Grover and it eventually went to Captain Patrick Mackay, who renamed the property Hermitage. Construction of the mansion, pictured here around 1900, commenced in 1819. At the time it was owned by Henry McAlpin, who had acquired the land in 1815.

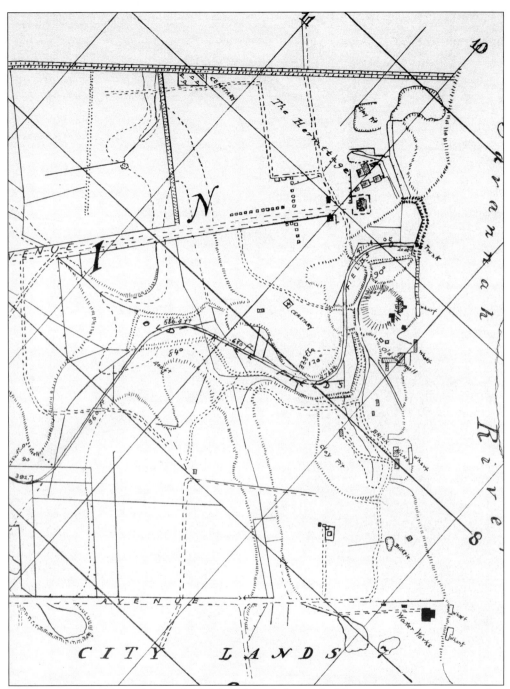

This map, dated 1819 and drawn by R.V. and Ford, shows the Hermitage under the ownership of Henry McAlpin. Seen here are many of the structures on the Hermitage, ranging from the mansion to slave cabins. Also depicted on this map is a cemetery, probably the McAlpin Family cemetery.

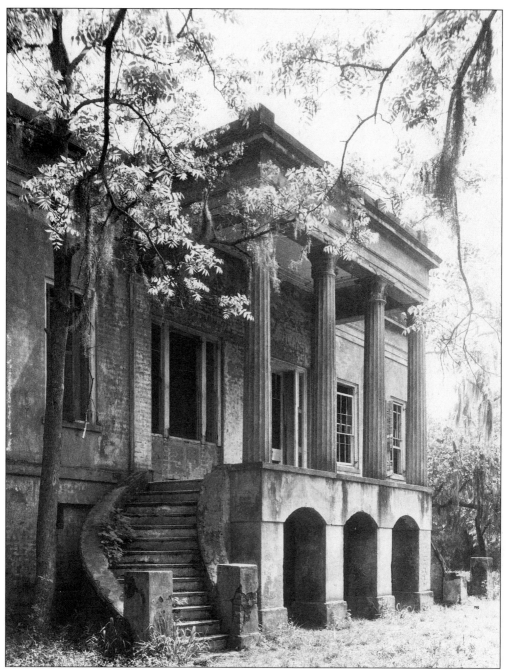

During the Civil War the Hermitage was ransacked but not destroyed. The site never regained the prominence that it had once enjoyed. McAlpin's descendants attempted to restore the house and returned to the Hermitage in 1894. This photograph was taken in the early 20th century.

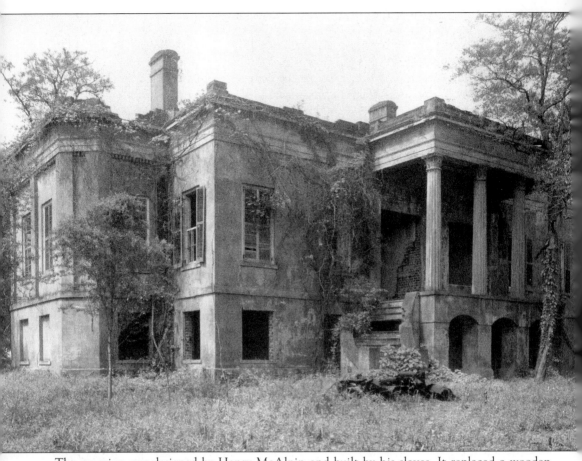

The mansion was designed by Henry McAlpin and built by his slaves. It replaced a wooden house which had stood for many years. The marble stairs, the marble mantles, and the slating for the roof were imported from Europe. Most of the building material was made on the plantation.

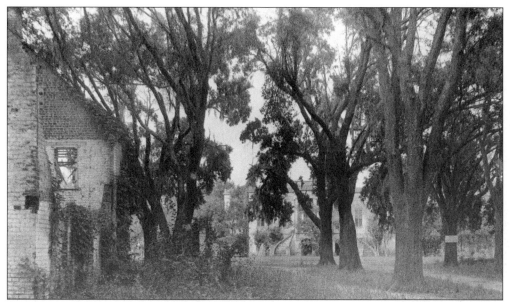

McAlpin's plantation was the first on the Savannah River to turn a profit from industrial, rather than agricultural, pursuits. McAlpin became involved in the lumber business but made his largest profit in the brick-making industry.

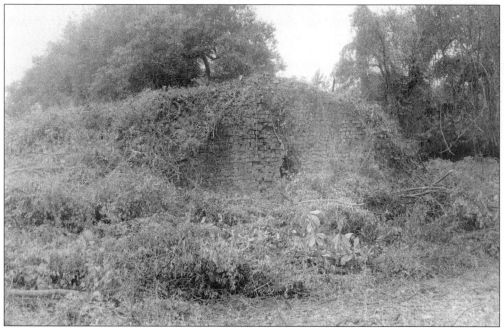

Pictured here is one of Henry McAlpin's brick kilns. The photograph was taken about 1907. McAlpin understood the need for bricks in Savannah, and he utilized the area around him to manufacture Savannah Grey Brick. Due to his brick-making, Georgia can claim the site of the first railroad. In 1820, McAlpin needed to move a building from one kiln to another. He designed and constructed a rail transportation system. After the building was moved, the rail line was dismantled. This event took place six years prior to the claim of the earliest railroad in the United States.

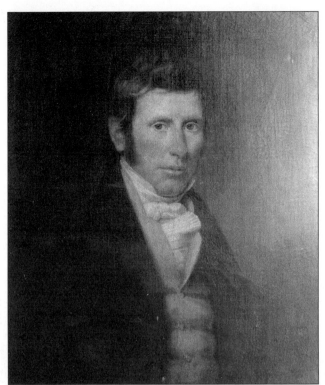

Pictured here is Henry McAlpin. His is the name usually associated with the Hermitage. McAlpin died in 1851 and was buried in a cemetery on the Hermitage land. He was later removed and interred in Colonial Cemetery. Following his death the Hermitage stayed in his family until the early 20th century.

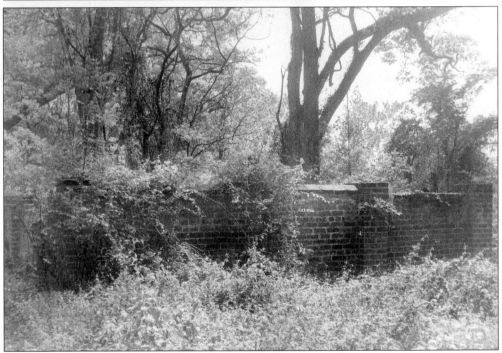

This photograph, taken in 1907, is of the cemetery at the Hermitage. The location of the cemetery is shown on the map on page 92. The cemetery was near the boundary between Brampton and the Hermitage. This cemetery does not exist today.

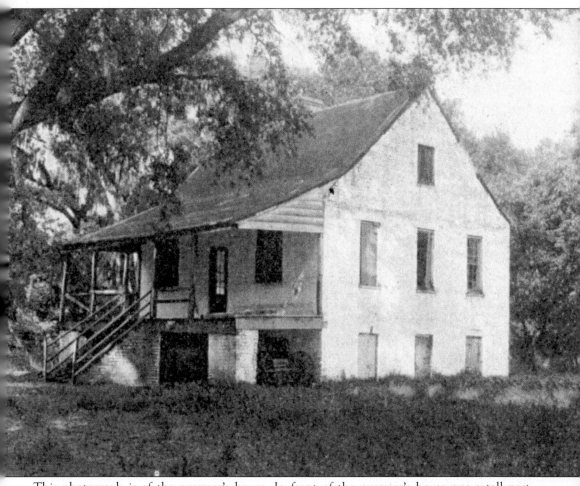

This photograph is of the overseer's house. In front of the overseer's house was a tall post approximately 18 inches in diameter. On the post was a clear-toned bell which could be heard over the entire plantation.

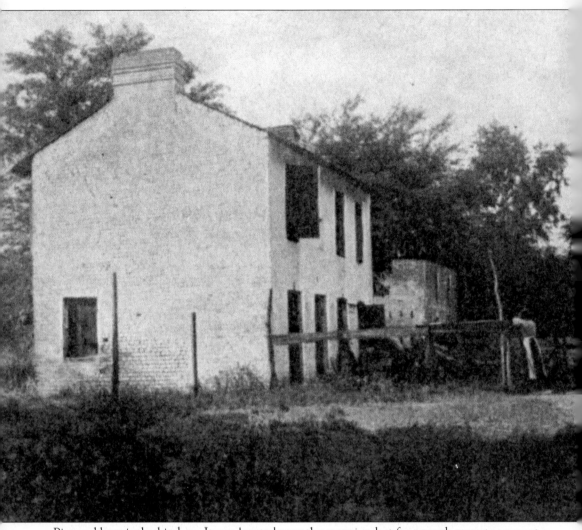

Pictured here is the kitchen. It was located near the mansion but far enough away to prevent a kitchen fire from becoming a total disaster. In addition to the kitchen there was a smokehouse. Hog meat was a primary part of the diet of those living on the Hermitage. The hogs that belonged to the Hermitage were raised on an island opposite the plantation. The island was identified on several early maps as "Hog Island." McAlpin purchased the island in 1818.

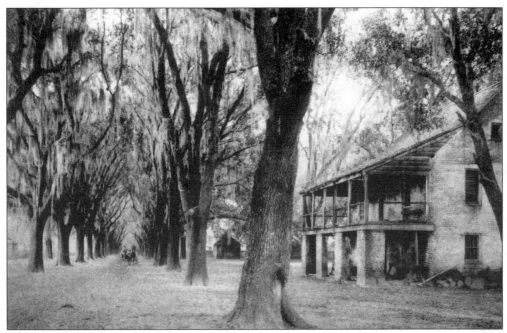

Pictured here is the plantation hospital. The top photograph was taken around 1900 and the bottom photograph was taken several years later. The second story of this building was used as a ward for men and a ward for women. Henry McAlpin contracted with a Savannah doctor to make visits to the hospital and care for the slaves as well as his family.

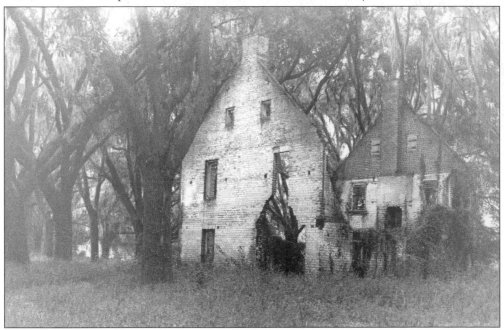

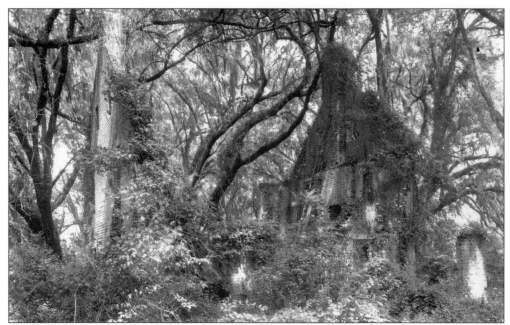

The lower floor of the hospital was where babies were cared for by the older slave women who were considered too old to work in the field. During the day a bell was rung to call the mothers from the fields so that they could nurse their babies. This photograph was probably taken in the 1930s.

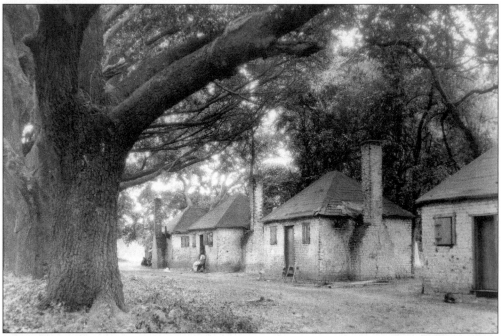

This photograph, taken in 1933, shows the houses that were used as the slave quarters. Each of these houses was made of brick and divided into three rooms. One room contained a large open fireplace and was used as kitchen, eating area, and sitting area. The other two rooms were the sleeping quarters. Usually one family was assigned to each house.

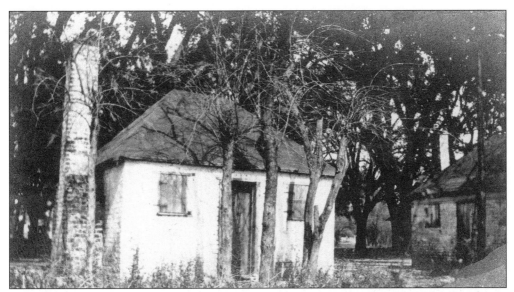

When Henry McAlpin died in 1851 he owned 227 slaves. Of these, 172 were on the Hermitage, 16 were in his city house, and 39 had been sent to work for his children. McAlpin had stipulated that he wanted the operation of the plantation to be carried out by his son Angus. Pictured below is a family of former slaves that remained on the land following the Civil War. The slaves remained on the property even though the McAlpin family did not return until much later.

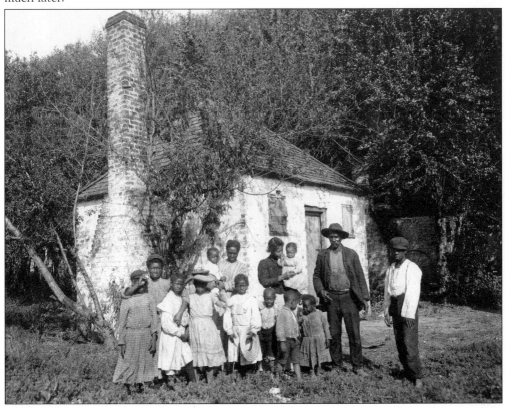

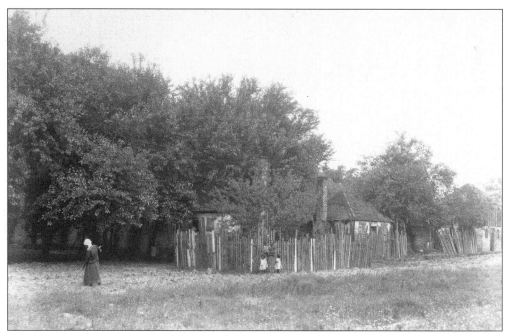

Each house was allotted a small plot of land on which the slaves were allowed to raise whatever they desired. Some chose to plant flowers, while some chose to either grow vegetables or raise poultry. If they produced more than they needed, Henry McAlpin would purchase their goods at fair market price. These two photographs are of the fields behind the slave quarters. Both of these pictures were taken in 1933.

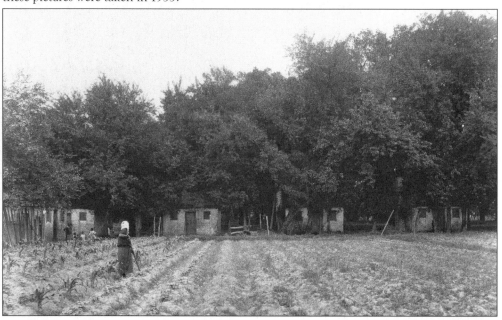

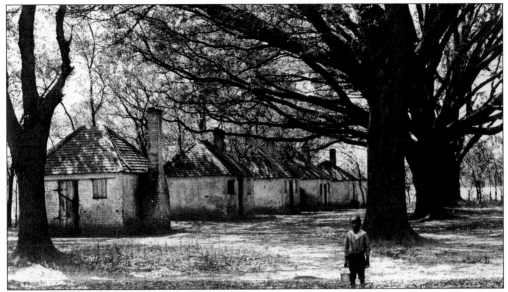

During the ownership of Henry McAlpin, the Hermitage was considered malarial in summer. This was common along the Savannah River, and usually about the middle of May the family would move north and/or farther inland. They would not return until the first killing frost. Numerous slaves, especially mothers, babies, and children, were moved to McAlpin's pine lands and returned after the frost.

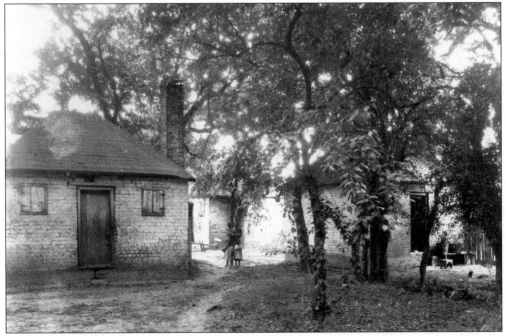

During the Civil War the McAlpin brothers lost the plantation to Aaron Champion, father-in-law of James Wallace McAlpin. The estate was practically in financial ruin, and Champion purchased it at auction in 1866 for $6,000. He conveyed the land to James McAlpin in trust for his daughter Maria and her children. In 1889 James McAlpin conveyed a right of way to Chatham County for constructing a public road.

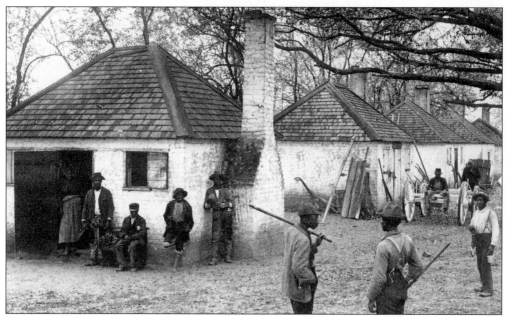

Upon the death of Maria McAlpin, the Hermitage went to her three sons and two daughters. In 1895, 120 acres of the Hermitage adjoining the old City Water Works were conveyed to the Savannah Railroad and Terminal Company in exchange for shares of stock. In 1897 this land was returned due to the lapsing of the railroad company's charter. This photograph of the slave quarters and these men was taken in 1908.

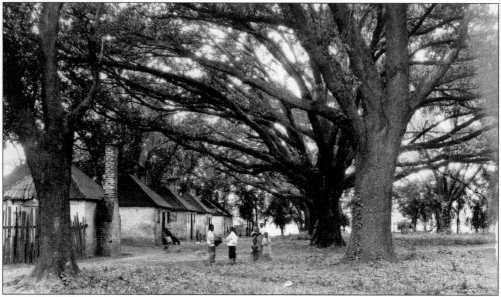

At the end of the 19th century the mansion at the Hermitage was once again occupied. Henry McAlpin married Isabel E. Wilbur. They moved into the house, which had been restored in 1894. Many of the furnishings were passed through the family, and the McAlpins entertained Savannah's society. Eventually, Isabel McAlpin found living at the Hermitage inconvenient, and they moved to their house on Orleans Square. This was the last time that the Hermitage mansion was occupied.

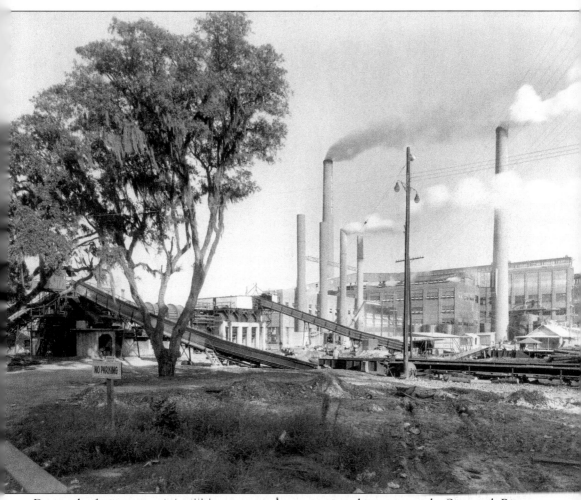

During the first quarter of the 20th century industry continued its move to the Savannah River land. The Hermitage was divided by the tracks of the Seaboard Airline Railway. Sometime after 1910 Judge Henry McAlpin, Maria McAlpin Schley, and Mary E. Walker, the heirs of the Hermitage land, formed the Hermitage Corporation to protect their interests and to handle property transactions. This photograph, taken in 1937, is of the Union Bag and Paper Corporation, located on the Hermitage land.

Judge Henry McAlpin died in 1931 and his interest in the property was transferred to his wife and daughter. McAlpin was extremely attached to the property and it is doubtful if it would have ever been sold while he was alive. In 1934 the Savannah Port Authority began purchasing land previously included as part of the Hermitage. On February 28, 1935 all of the land had finally been purchased by the Savannah Ports Authority. These two photographs were taken in 1937 and are of different views of the construction of the Union Bag and Paper Corporation facility.

In June of 1935 the Savannah Port Authority gave the Union Bag and Paper Corporation of the State of New Jersey a 99-year lease on the Hermitage with an option to purchase. The terms of the transfer were $1.00 and "valuable considerations." Shortly thereafter the land was transferred to the Union Bag and Paper Corporation of Georgia. Construction of a large paper mill began almost immediately upon the transfer. The plant was constructed on the water front near the site of the mansion. These two photographs were taken in 1937 during plant construction.

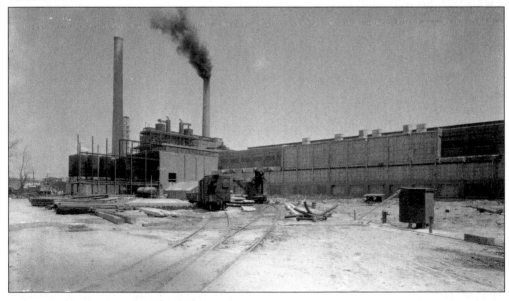

The Union Bag and Paper Corporation eventually became known as Union Camp. The Hermitage land was always used as an industrial site, as the plant was constructed on the first industrial site in Georgia. Visitors to the Hermitage were more apt to hear the clang of machinery rather than the raking of a hoe or swish of a scythe. These two photographs of Union Camp were taken in February 1998.

In 1935, with the sale of the Hermitage to the Savannah Port Authority, it was decided that the buildings on the Hermitage would be sold to automobile magnate Henry Ford. Ford had made an offer and received the structures for $10,000. Prior to the sale to Ford, Harold L. Ickes, secretary of the interior, wrote the mayor of Savannah to express his thoughts on the buildings. Ickes felt that the plantation needed to be saved and that the buildings must be maintained on the same site. These photographs of Union Camp were taken in February 1998.

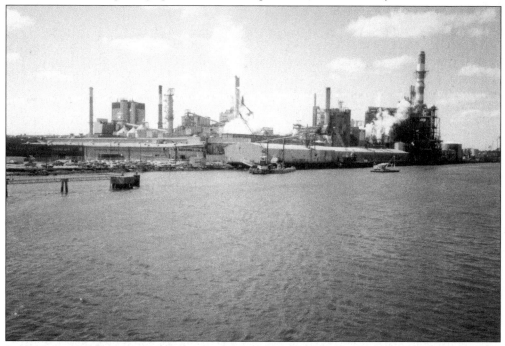

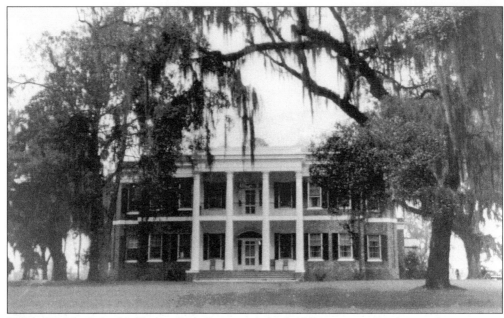

Henry Ford had the buildings taken down and the building materials taken to his estate in Bryan County, Georgia. He used the building materials in the construction of his residence, pictured above. This house is currently a private residence.

In addition to the removal of the Hermitage mansion, Ford had two slave cabins carefully dismantled and shipped to the Ford Museum in Dearborn, Michigan and reconstructed in detail. Henry Ford had a tremendous impact on Richmond Hill, Georgia, originally called Way's Station. Pictured here is Ford observing students at a school that he constructed in the community.

Ten

VALE ROYAL

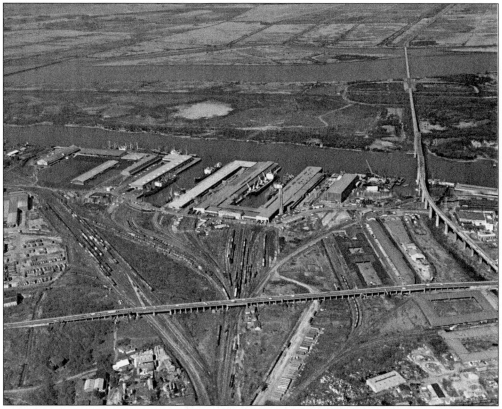

The first plantation upriver from Savannah was Vale Royal. This plantation was sometimes referred to as Royal Vale. The 1,000-acre tract was originally granted to Pickering Robinson and his brother Thomas in the 1750s. They came to Georgia to promote the silk culture. This aerial photograph, probably taken in the 1960s or 1970s, shows part of the property looking toward the Savannah River.

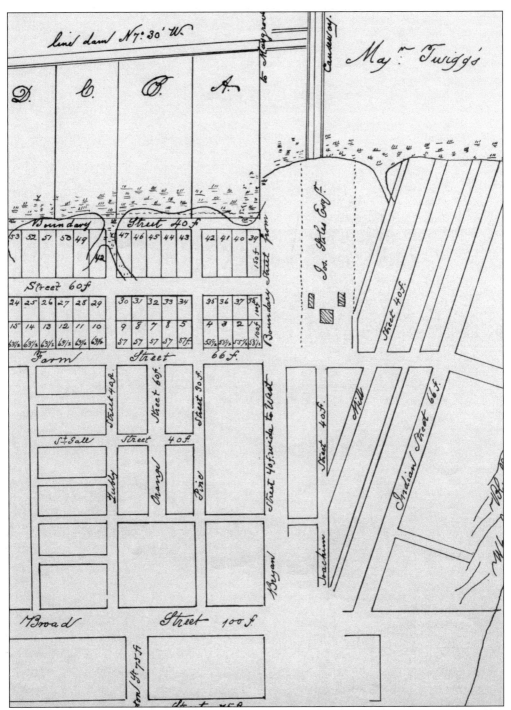

This map, drawn by John McKinnon in 1818, shows the area of Vale Royal closest to the city. Vale Royal was bordered by the garden and farm lots of the City of Savannah on one side and the Hermitage on the opposite. The eastern boundary was called Farm Street and is today known as Fahm Street. The house that was built on Vale Royal was on the Savannah side of the property.

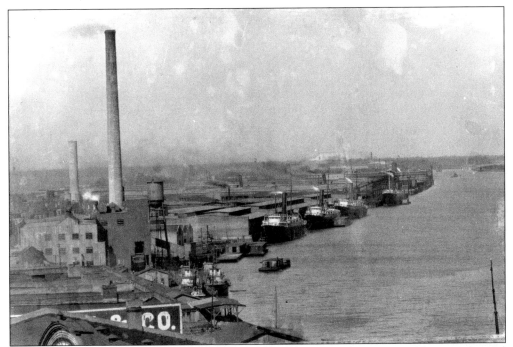

This photograph was taken in 1925, looking upriver from city hall. The area beginning on the other side of the smokestack is Vale Royal. In 1762 the land was conveyed to Lachlan McGillivray, who named the plantation. He tried his hand in agricultural endeavors but returned to Scotland in 1770. This land was seized following the Revolutionary War.

This view of the lower portion of Vale Royal was taken in March 1998. The house, built by Joseph Clay, who purchased the land in 1782, stood on the other side of the large white building in the center of this photograph.

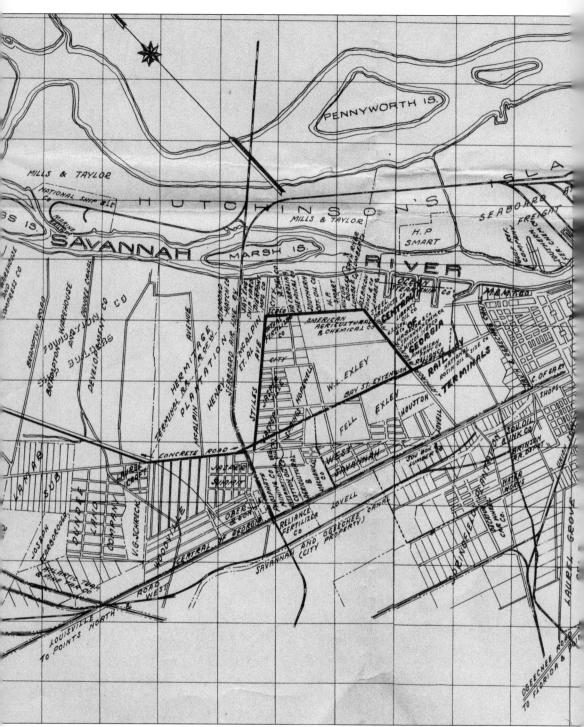

This 1919 map, drawn by W.F. Shellman, shows how the industry expanded up to the city limits. At the time of this map Vale Royal was used primarily by the Central of Georgia Railroad terminals and the Ocean Steamship Company. Bay Street Extension would run right through the house built by Joseph Clay.

114

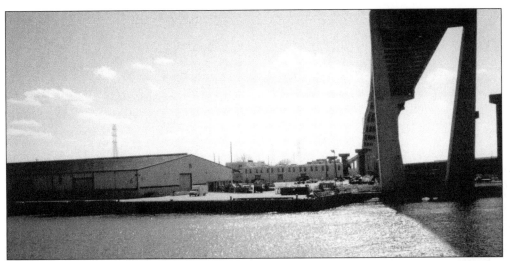

This view, as well as the one below, was taken in March 1998 from the river. After Joseph Clay died, the land moved to the possession of Joseph Stiles in 1804. In 1818 Stiles was forced to cease rice cultivation, as a state law made it illegal to have wet rice culture so close to a city.

This photograph is of the Diamond Manufacturing Company. Vale Royal became linked to a tragedy in the Revolutionary War in 1778 as the British attacked the city. Local militia fled toward Musgrove Creek. They were pinned in at high tide and attempted to cross the creek. Thirty men drowned.

Joseph Stiles died in 1838 and his land was sold off beginning in 1839. This area became important as railroad spurs were laid. The Stiles heirs still owned some interest in the land, and the Civil War ended the plantation era on Vale Royal. In 1872 the Stiles heirs sold the remaining land, and in 1879 the Central Railway and Banking Company purchased the land for tracks and wharves. Some of the higher land became subdivisions. These two photographs were taken in February 1998 in the general area of the house and outbuildings.

Eleven

CAUSTON'S BLUFF

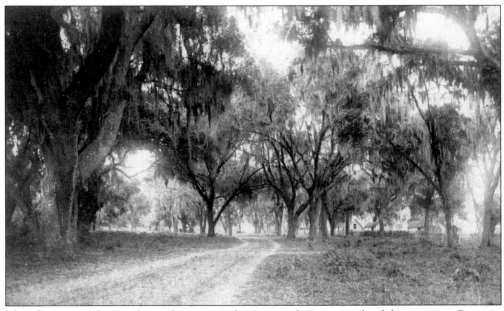

The plantations that made up the area on the Savannah River south of the city were Brewton Hill, Deptford, and Causton's Bluff. The land consisted of 2,500 acres and was also referred to as Deptford Tract. This photograph, probably taken between 1890 and 1910, is of the road to Deptford.

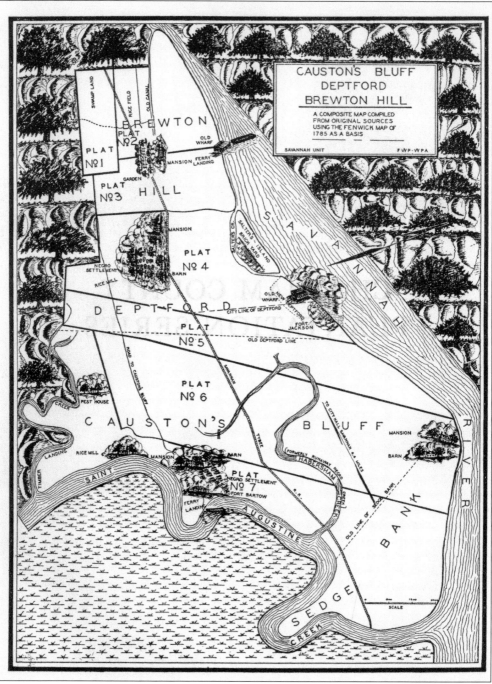

CAUSTON'S BLUFF
DEPTFORD
BREWTON HILL

A COMPOSITE MAP COMPILED
FROM ORIGINAL SOURCES
USING THE FENWICK MAP OF
1785 AS A BASIS

SAVANNAH UNIT F.W.P.-W.P.A.

This map shows the locations of the buildings of the three plantations. Also included is the Savannah and Tybee Railroad. Causton's Bluff was an early leader in rice cultivation on the Savannah River. However, dredging of the river eventually led to brackish water entering the rice fields and destroying the crop. By 1910 there were no attempts to cultivate rice. The property is bordered downriver by Saint Augustine Creek. There are no plantations between here and the mouth of the river.

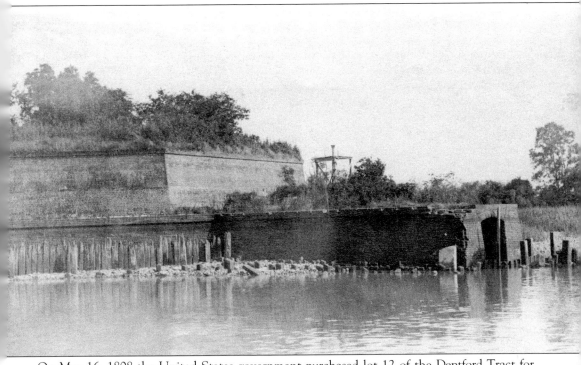

On May 16, 1808 the United States government purchased lot 12 of the Deptford Tract for $1,800. This lot was for the construction of a fort which was eventually called Fort Jackson, in honor of General James Jackson, who had been a governor of Georgia. Today the fort is operated as a historic site by the Coastal Heritage Society in Savannah. This photograph was taken in 1910.

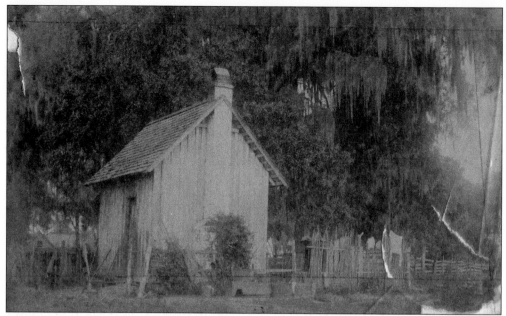

Deptford changed owners rapidly. In 1885 it was sold to John C. Rowland and Captain D.G. Purse. For the most part Deptford was idle between 1908 and WW I, when shipbuilders began to use the land. In 1877 some of the land was purchased by the city to construct a pesthouse. A pesthouse was used for people who had to be isolated due to communicable diseases. These two photographs were taken by W.E. Wilson in the late 19th or early 20th century. His description of the photographs states, "slave cabins at Deptford."

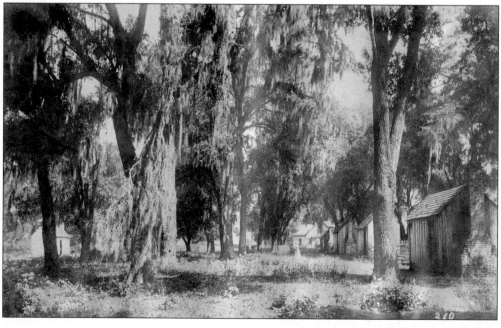

This photograph of the Atlantic Coastline Railroad built on Brewton Hill was taken in 1888. The land was owned by John, Thomas, and George Screven, who all saw the financial benefit to giving the railroad use of the land. Railroad wharves line the river for almost half a mile. The terminals stood a short distance to the south, and to the west stood Le Pageville, which was occupied by blacks working for the railroad.

This March 1998 photograph shows the remnants of the spectacular wharves constructed on Brewton Hill.

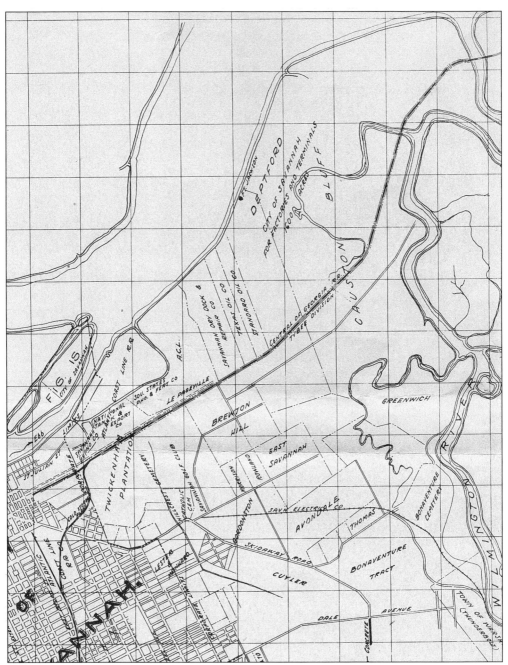

In 1919 the Causton's Bluff area was an industrial site. Land speculators had been right about the potential profit from this land, as the area became industrial. The city anticipated eventual construction in the area that they owned. The railroad running through the property was extremely profitable to the land owners and/or industries.

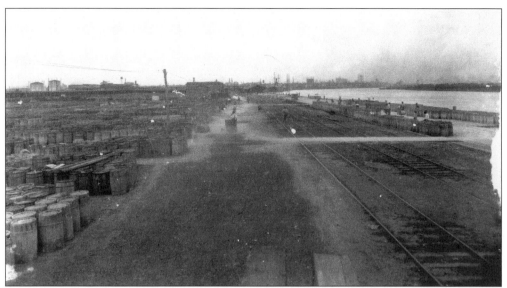

These two photographs are of the Atlantic Coastline Railroad rosin yard. These photographs were taken in 1924 and provide an amazing glimpse at the amount of naval stores shipped from Savannah. The city can be seen in the distance on the top photograph. Not far from this site is Salter's Island, which was granted to Thomas Salter in 1741. Salter was a brick maker and eventually deserted his tract and moved to Hutchinson's Island, as he felt that the clay was superior.

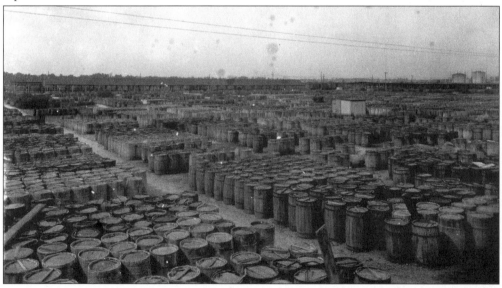

Convict labor was used to construct the railroad through the Deptford Tract. These two photographs were taken in 1933. One interesting event that occurred at Causton's Bluff in the 18th century involved the Reverend John Wesley and Sophia Hopkey. Hopkey was romantically interested in Wesley and he felt the same. However, he showed no signs of marrying Hopkey and she eventually married William Williamson, who was interested in acquiring the land where she lived. Wesley refused to give Hopkey communion, and this led to an uproar in the colony causing Wesley to return to England.

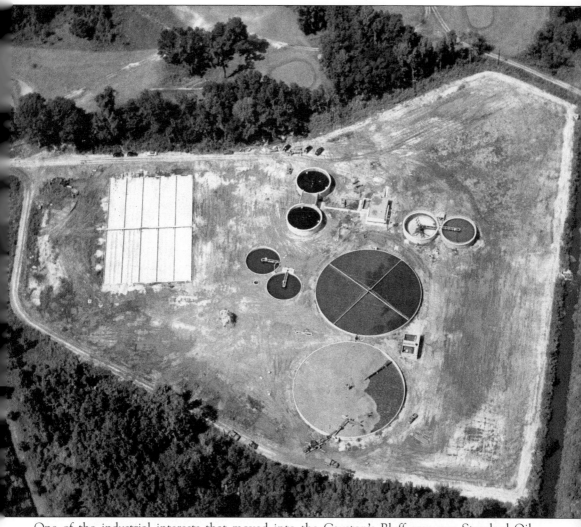

One of the industrial interests that moved into the Causton's Bluff area was Standard Oil Company. The industry built along the riverfront and near the Standard Oil site can be seen on the map on page 122.

These two photographs were taken in February 1998, looking across Saint Augustine Creek. Today this area is occupied by a subdivision of custom homes called Causton's Bluff. The majority of the remaining Causton Bluff land is occupied by industry.

INDEX